VAN GOGH

LARA VINCA MASINI

THAMES AND HUDSON

Translated from the Italian by Caroline Beamish

This edition © 1967 Thames and Hudson Ltd, London
Copyright © 1967 by Sadea Editore, Firenze
Copyright © 1980 by Scode, Milano

Published in the United States in 1989 by Thames and Hudson Inc.,
500 Fifth Avenue, New York, New York 10110

Library of Congress Catalog Card Number 89-50747

Printed in Italy

Life

Van Gogh's life, like his work, is now part of a myth; he is in fact generally placed among the last few heroes of the romantic world to be haunted by an implacable curse. The signs of a singular destiny have been looked for in the most trivial particulars, the most banal aspects of his life, which was much like any other life, if undeniably more unfortunate and more intense. His origins have been minutely examined: his father, Theodorus van Gogh (1822-85), was the incumbent of the parish of Groot-Zundert, in the Dutch province of Brabant, where Vincent was born, on 30 March 1853, into a family of clergymen and goldsmiths.

People have tried to gather, from a fairly uninspiring childhood, signs of what could have formed Van Gogh. Everything has contributed to the myth; and thus has helped to ruin for ever any chance of getting close to one of the most disconcerting and genuine figures in modern art, a man who was exceptionally aware of the actual problems of his time, both historically and culturally, and – which explains nearly all the eccentricities of his life – acutely sensitive to the social crisis of the moment. His life, from childhood to adolescence, was absolutely ordinary. At sixteen he was employed by Goupil (a well-known art dealer for whom several of his relations had already worked, and who was later to employ his brother Theo) at The Hague, and in 1873 he was transferred to London, where he was to have his first disappointment in love. Ursula Leeger, his landlady's daughter, turned down his offer of marriage. This precipitated the second stage in his life: a search for a purpose to his own existence: which resulted initially in a sense of religious vocation. From now on he was to be dogged by failure: at the entrance examinations for the faculty of theology at Amsterdam University, and at the school of practical evangelism in Brussels (1878). Then came his violent experience as preacher among the miners in Borinage, the most squalid of mining villages (the Belgian

'black country'), where, refusing any sort of compromise, Van Gogh became more humble than the humble, renouncing everything – house, clothes and food – in an excess of generosity which was naturally neither accepted nor understood even by the miners. He overwhelmed them with cures and evangelical fervour; they loved him but failed to understand his excessive zeal. During an epidemic of typhoid he succeeded in curing one case of it; at the height of the outbreak he lived night and day in the mines doing what he could to help, giving away even the few rags he wore for bandages. But it was during this winter, in the most appalling material and psychological conditions, that he was to find his true vocation.

Then followed his intensive training (1882-5) under the Northern masters, his Parisian experience (1886-1887), his coming to terms with himself in the solitude of Arles (1888), his refuge in the Saint-Rémy hospital (1889) and his last stay in Auvers (1890) with Doctor Gachet. A life incessantly tested, passed in the darkest misery, with the help of only his brother Theo who supported him as best he could (but basically Theo's resources were only those of a simple employee of Goupil in Paris, who during all Vincent's life was to sell only one of his canvases, the *Red Vine*, and that the year before he died).

All Vincent's life was to be punctuated by his 'gestures': first another unrequited love for a young widowed cousin led him to beg her parents to allow him to contemplate her for as long as he could keep his hand over the flames of a petrol lamp (he bore it for longer than one would think possible, then fainted: 1881). He rescued and took in to live with him a wretched prostitute (Sien) and her five children, hoping to be able to save her; naturally he did not succeed. In Paris (1886) in order to free Theo, Vincent offered to take over his mistress, and even marry her.

At Arles, after some heated, violent arguments with Gauguin, who came to join him there and lived with him (October-December 1888), he was once again to make a gesture. It was, as always, a gesture against himself, this time almost a punishment for an act of rebellion against his friend, who fled overpowered by his personality which was

4

weaker (Gauguin was extrovert, egotistical and domineering) but equally more intense and sensitive, shut-in and jealous, and capable of the most frightening sudden outbursts. With a razor Van Gogh cut one of his ears off, and, having washed it and wrapped it up, he presented it to the porter of a brothel, as a gift for one of the girls. Basically it was this violence against himself (towards others he was always unfailingly generous), this wish never to spare himself anything, which undermined his health, destroyed him as a man, and led him to his last carefully planned gesture of self-destructive violence. In the sunny solitude of the July fields (on 27 July 1890), the fields which he painted in every season like a basic symbol of life, to the point of distorting them in the violence of his inner ferment, he shot himself fatally in the chest.

'There will never be an end to sadness', he said to his brother, who had hurried to his death-bed from Paris.

His letters remain a continual and extraordinary testimony to all the moments of his life, from 1882 on; most numerous of all are those to his brother Theo, his other self, who bore all the repercussions of Vincent's fortunes, who helped him incessantly, in every possible way, and never lost confidence in him; and who once Vincent was dead – even though he had been married a year, and had a very small child – could not bear to survive him, and so followed him, less than six months later, maimed and destroyed both in mind and body. There are also letters to his friend Émile Bernard, and to Van Rappard, only published in 1950; a few to his mother, and to his sister Wilhelmine, also exist. From the letters one receives an extraordinary impression of gentleness, human warmth, a completely open and uncalculated abandon to his own moral and artistic ideals, so that if people had not too often allowed themselves to be misled by his apparent aggressive violence – and this was only enthusiasm, an insane love bordering on mystical exaltation for both art and life – Van Gogh's place in the history of art could have been assessed long ago. On the other hand there is also the danger of being led astray by the strength, albeit poetic, of these letters. There is, however, no question that the first documents to turn to in the

study of Van Gogh, alongside his work and as a guide to it, are these extraordinary, very human letters, this 'journal' which he poured out almost daily, in a direct speech to the outside world.

Works

' Once upon a time it was thought (or perhaps merely suspected) that each person carried with them their own death, like the fruit its kernel. Children had a small one, adults a large one. Women carried them in their laps, and men in their chests. Everyone had their own – and this gave to each individual a particular dignity, a silent pride...
' This excellent hotel is very old; as far back as the reign of Clodoveo people were dying in bed here. Nowadays people die here in five hundred and fifty-nine beds. In rows, naturally. Given the prodigious number of births, each individual death is not too carefully recorded – but what does this matter? It is the multitude that counts. Today, who bothers any more about dying gracefully? The wish to have a personal death becomes ever more rare. If we go on like this much longer it will become as rare as the wish to have a personal life. '

It was not yet twenty years after Van Gogh's death when Rainer Maria Rilke wrote the *Notebooks of Malte Laurids Brigge* (1904-10), recording in his turn one of the moments of subtle tension in the degeneration of romantic thought. It is precisely in this light of rather precious decadence that, until a few years ago, Van Gogh has been interpreted. As for his letters, which are a rich and painful testimony of his private life and obligations as an artist – inseparable and completely identified one with the other. Too often the poetic declarations that they contain are confused with the work itself, just as the life is explained through the work and *vice versa*.

The real problem, however – and this is what recent criticism is trying to do – is to transform what has hitherto been considered a *débâcle*, the breakdown of an individual – strangely in contrast to the overwhelming, if posthumous,

triumph of his works – into a conquest of freedom; this involves bringing to light the phenomenon that was Van Gogh, in all its entirety and complexity, as symbol of the rediscovery of the freedom of man through art, man himself as redeemed by society.

' There are signs of death in modern art. Van Gogh's painting and Rimbaud's poetry destroy their own framework at the very moment they are building it; one talks of the poetry, the music of silence. But at the very instant in which the art form is burning itself out, its aesthetic value is shining with a dazzling brilliance. The cycle is extremely rapid: just as the spark of a short circuit destroys the plant, so the value destroys the experience that produced it. Thus the intrinsic value reveals the negative and not the positive assertion of the experience. Let us take Van Gogh's *Sunflowers* (*pl. 34*). For a number of complicated reasons this yellow flower appeared to the artist as a problem of existence: that is to say it represented to the artist the problem of his own existence. Van Gogh resolved it with a symbol: the problem resolved by the symbol is that of existence, of *being there,* of existence-in-relation-to, of the presence of the sunflower in the context of natural forms.

' He resolved it in the sense that the painted sunflower is the symbol of an isolated concept, " sunflower ", entirely subtracted from any contact with nature: it is no longer a thing belonging to reality, but reality itself.

' This might seem nonsensical; existence entails relationships; by denying them you necessarily condemn existence. But existence can be asserted in a more fundamental sense. Van Gogh painted from real life; but the process of imitation destroyed itself because he saw in each relative object an absolute one. However Van Gogh did not go beyond the circle of existence. There is in fact a moment in existence when all relations can be discarded, and the idea of *in, with* or *for* ceases to exist for something which exists ' in itself '. At that moment each person's experience is individual, devoid of any spatial or temporal relationships. This is the instant of death, when existence is not identified with life but with death. And here lies Van Gogh's (and Rimbaud's) discovery and gift to mankind: death belongs to

mankind. Death is part of existence; more than that, it is the moment of self-existence, of absolute existence. Perhaps all art is only the expression of the need to make present and so clarify death. Today we have a precise consciousness of this imminence of death in art. Today art is more than ever in a state of struggle against death; and just as freedom is not an abstract entity, but a liberation from something which oppresses us, so life is conquered from the threat of death, redeemed from death to the cycle of existence. More exactly, in art, or with art, is defended the right of each individual to *live* his own death instead of *receiving* it passively from whoever takes it upon himself to administer and bestow it, so defying the threat. Lastly, with art, one is fighting for a total existence, which also includes the experience of death, against all the experiences which are attempting to make of death an instrument of moral force, both on the political and the religious planes. But, by alienating death from existence, and as an attribute of existence, art breaks off relations with the past, sets itself up as a new code of values, brings about a revolution, since the act of revolution is one which is carried out in the presence of death, there being no other alternative' (Giulio Carlo Argan).

It is thus a question of seeing how in Van Gogh's work life and death merge into one, and that what Shapiro calls ' choice made for his own personal salvation' is in fact total commitment, the precise ethical code of a modern artist, a creator of standards of behaviour; one must also understand how in Van Gogh painting is transformed into an existential act, and how he stands traditional artistic logic on its head and works it out again in the light of a new and extremely rigid existential logic, carrying to its furthest limits the break with all impressionist premises. In this sense one can speak of Van Gogh as an artist of reality, while taking into account his continual displacement of objects in nature, his ' layers of consciousness ', his way of reminding one, in every gesture, of the desperate human condition.

' Even Van Gogh's choice of colours is mental, though the aggressiveness of his attack on naturalism is totally sensory.

Where Cézanne merely accepts the impossibility of representation using recognized means, Van Gogh actively flaunts it. A rock, or a field of wheat, becomes a cosmic tragedy; Van Gogh imprints on every stone, every leaf and every ear of corn a raging torment, his own torment, his own despairing anxiety' (Nello Ponente).

For this reason one can talk of 'realism' (as opposed to 'naturalism') in his case because nature becomes for him a symbol of absolute reality. 'I am not in the real life, in the sense that I should rather work in flesh than in colour' (letter to his brother, 1888).

Realism in Van Gogh's work, in the accepted sense of the word, was reserved for his Dutch period, his years of rigid preparation between 1880 and 1885. It was the moment of his 'black painting', when he was most deeply involved in painting scenes of social conditions, while he was still under the influence of his frustrated religious vocation. Even then it was a form of realism that one can describe under the heading of 'imaginary Dutch realism'. His palette was based on the customary tones of the northern painters, earth colours (ochre, Siena) which appear in the traditional manner of direct referral to the great Flemish masters of the seventeenth century. His landscapes of that date, his beaches (*pls. 1-3*) are painted in warm, golden tones. The composition of the picture is still classical, with the line of the horizon half-way down, and distinct relationships of light and shadows. His interiors of weavers and peasants caught in their daily attitudes of work are based on classical perspective, with its central vanishing point. The minute and descriptive attention paid to detail (his still-lifes are already a symbol of human presence), and the distribution of solid objects under the light are part of the long tradition of northern figurative imagery which can be traced to Rembrandt and Franz Hals and which can equally be discovered in the dramatic obsession of Ibsen's theatre, for example, and through expressionism, in that of Strindberg; it also constitutes the symbolical roots of the slow close-up camera shots of interiors in Carl Theodor Dreyer's *Dies Irae* or *Ordet*, and – to keep to cinematographic imagery – it is also the basis, albeit transformed into a question of fashion,

of the expressive forms of certain of Ingmar Bergman's films.

But Van Gogh's finest penetration into human expression, in the form of an exact transcription of reality (the means were later altered), is in the famous canvas of *The Potato-eaters,* painted in 1885 (*pl. 8*), and in the various works, studies and drawings (*pls. 4-6*) of which *The Potato-eaters* is the culminating result. In this admirable piece of Dutch painting (' And so, though painted in a different style, in another century than the old Dutch masters, Ostade for instance, it too comes from the heart of the peasant's life, and is original ' letter to his brother: May, 1885), the play of light and shadow is already arbitrary, and the deformations almost caricatures, obeying a lyrical expressionism which had its roots in the realistic-fantastic Flemish traditions, and which preceded the overthrowing of classical rules which was to come very soon after. The light is already unreal, the figures absorbed into a reduced and intense space, the symmetry of the centre, based around the central lamp, is already thrown out by the vertical break of the walls which splits the scene up into two unbalanced halves.

The attention paid to details, which are stressed symbolically – the large gnarled hands, the irregular features, the emotional expressions (' I much prefer painting people's eyes to cathedrals ') – already points to a characteristic which was to remain constant across all his work. It is at this point that he turned towards the 'painters after his own heart '. ' Instinctive by nature, and autodidact by vocation, he needed to choose masters more as symbols of protection than as models of technique ' (Charles Estienne). This is how his predilection for Millet can be explained, which in fact led him to change his preoccupation with social themes, but he also saw in Millet's artistic experience a symbol so deeply felt that it transcended reality, while Delacroix incarnated for him expression obtained by colour and the dynamics of form. This also explains his love for Dickens and Zola, as representatives of a social consciousness which in Van Gogh was almost always the product of emotion. Van Gogh's socialism was deeply felt, but understood in

the sense of an utopian, vaguely romantic humanitarianism which he shared with many of the intellectuals of the day. He transformed it from an ideology with precise political applications into an indirect source of artistic inspiration. Reality, for Van Gogh, becomes an interior dimension, the occasion for an intensive quest for truth. Just five months before his death, on 12 February 1890, he wrote to Theo, *a propos* of an article in the *Mercure de France* by Albert Aurier, 'But it is so dear to me, this truth, *trying to make it true,* after all I think, I think, that I would still rather be a shoemaker than a musician in colours.' Van Gogh's concern with reality did not lead him to protest or denunciation, such as is apparent in the work of the later expressionists, such as Nolde and Munch, who drew inspiration from his subtle balance of line and colour; he accomplished the transfiguration of the real into the symbolic, the object into the *idea* of a gesture, the *idea* of a colour.

This was Van Gogh's great discovery of the use of colour to give direct expression to an idea, a discovery which was to influence both the Nabis and the fauves, Van Gogh's lineal descendants (by way of Gauguin). Together with contributions from Seurat and Gauguin, this discovery was an essential constituent of Art Nouveau, a style which contributed its own visual grammar based on the emancipation of the undulating line and the calligraphic extenuation of the visual sign.

Van Gogh broke his last links with realism and the academic tradition half-way through his Paris period. He found Paris full of action, and enthusiasm, a climate of rebellion and determined change. In 1886 alone, four important exhibitions representing the different techniques of the moment were put on. In the Salon de Mai, among the academic portraits and fashionable pictures, he saw canvases by Puvis de Chavannes and Albert Besnard, who had tried to produce an inoffensive medium between middle class traditions and a sort of 'modernism' acceptable to the ordinary public. At the eighth Impressionist Exhibition he discovered Seurat's *Grande-Jatte*, works by Signac, Pissarro, Odilon Redon, Degas, Gauguin, Guillaumin, Berthe Morisot and Schuffenecker. In June, at the fifth international exhibition

in the Galerie Georges Petit, he found, gathered together with Renoir and Monet, some of the fashionable celebrities from Boldini to Besnard, Jacques-Émile Blanche and Raffaëlli. The Salon des Indépendants, in August, collected together all those who refused to accept the judgments of the Salon de Mai, with once again Seurat with the *Grande-Jatte,* and Redon, Rousseau, Camille and Lucien Pissarro. There were also the individual and group exhibitions arranged by the dealers Durant-Ruel, Georges Petit and Goupil. Also in 1886, Zola published *L'Oeuvre*, a novel centered around the cultural and artistic life of Paris. And finally, a fairly remarkable coincidence, given Van Gogh's affinity with current social problems, Verlaine published in the same year, in the literary review *La Vogue*, Rimbaud's *Les Illuminations*.

Van Gogh found confirmation and precise applications for his theories on the division of colour, and the use of complementaries (which he was to apply to symbolical-expressionist forms in his dynamics of the sign) in his discussions with Pissarro, who explained to him the impressionist concept of light and colour and Seurat's theory of complementary colours. In the basement of the gallery which his brother Theo ran for Boussod & Valadon, Goupil's successors, Van Gogh studied the works of Corot, Daumier, Manet, Renoir, Monet, Pissarro, Sisley, Guillaumin and above all Seurat and found support for his love for landscape studies in the *plein-air* of the Impressionists.

But he equally owed to Paris, after his first contacts with Antwerp which helped him chiefly to discover Rubens, his direct knowledge of the freehand brushstrokes of the Japanese prints which the Goncourt brothers had introduced to Paris, and a new abstract way of interpreting sign and colour, with a new perspective, entirely instinctive and absolutely opposed to the classical rules of the West.

As a result of these experiences Van Gogh's palette became clearer, his atmosphere lighter, and his colour fined down to a thin transparent veil. Even his subjects altered: the big retrospective exhibition of Millet in 1887 did not shake his predilection for one of his chosen masters, but his interest in him was no longer as direct. By now nature was pulling

him from within, like a cosmic force; the human gesture ceased to be symbolic in itself (he was to rediscover, in a completely transposed form, the significance of the existential act in his last period at Auvers). He was drawn towards the country of the south, Provence, 'the Japan of the south', which he learnt about from Gauguin's tales. Gauguin, this disconcerting character, cold, calculating, and yet violent and aggressive, so categorical in his revolutionary theories of colour, already surrounded by the aura of his exotic travels, was to have a strong influence on Van Gogh, and to play a large part in the tragic mental crises, that were later to unhinge his already unstable mind.

In 1887, Renoir showed his *Bathers*, in Petit's gallery, and there were canvases by Berthe Morisot, Whistler, Puvis de Chavannes and Rodin. Meanwhile the new Salon des Indépendants provided a fresh source of controversy. In Van Gogh's life this was the time of his study of flowers, of Japanese art, and of Parisian scenes (*Moulin de la Galette, pl. 11; Restaurant de la Sirène, pl. 18; View of Montmartre, and Asnières Bridge*).

With the clarification of his own expressive world, which found its most exact definition during his Arles period, its most moving expression in the last year of his life, spent between Saint-Rémy hospital and Auvers, Van Gogh gave a precise formulation of his socialist ideals. As he had once before in Holland, he dreamed of a union of artists, a sort of democracy of art obtained through communal work, an organization of teams, with a rigid division of labour, so as to stimulate an exchange of ideas and cultural information. This scheme, although utopian – its impracticability was sufficiently proved by the failure of the partnership between Gauguin and himself in Arles – probably had a more concrete and realistic basis than the later and perhaps rather too theoretical experiments of Morris, *De Stijl*, and the Bauhaus. Van Gogh was not an organizer, or a man of action. The *Atelier du Midi* remained at the planning stage, a testimony to Van Gogh's generous and optimistic ideas; even in this he showed himself to be opposed to romantic individualism. In June 1888 he wrote to his friend Émile Bernard, a young non-conformist painter, with whom he

had started in Paris an exchange of works 'like the Japanese painters'; 'I am more convinced than ever that, if painting today is to express itself fully and attain the serene heights reached by Greek sculptors, German musicians and French novelists, pictures should profit from more than the potentiality of one isolated individual; they should probably be carried out by groups of men gathered together with the aim of executing a communal idea. One man might have a superb orchestration of colours, but lack ideas. Another might be bursting with new, sad or exciting ideas, but not be capable of expressing them in sufficiently sonorous forms, given the unadventurousness of his palette. For many reasons, therefore, the lack of team spirit among artists is to be deplored; all they do is criticize and persecute one another, though fortunately they do not quite manage to cancel each other out.' As proof he cited the 'historical evidence of the artistic unity of the Renaissance.'

He also tried to discover the 'unique rhythm, the rhythm of the world' in the solitude of Arles, his 'Orient' as J. Leymarie has called it.

It was during his Arles period that Japanese prints, with their perspective based on superimposed planes (in which distance is conveyed by the top of the painting, presupposing the spectator to be looking from above), and the perspective of the medieval primitive and the modern '*naïf*', fascinated him and led him to translate his representation of space into a sort of total surface 'on a plane'. It was in the large wheat fields near Arles (*Yellow Wheat, pl. 54; Field of Little Yellow Flowers*; *Green Fields near Saint-Rémy, pl. 53; Corner of the Meadow*) that Van Gogh's language attained a sort of symbolical naturalism: nature became an element of substance and colour, and took over the picture in its entirety (a method years before its time) in a pulsating movement, a continual surface of vibrating signs. Today the analogy with the very recent abstract experiences in art is particularly striking.

Arles was also the period of large portraits, ranging from those of the Roulin family (*The Postman Roulin, pl. 32; Portrait of Armand Roulin, pls. 44-5; La Berceuse, pl. 49* which were followed by *The Schoolboy, pl. 62* and *Madame*

Roulin with her Child) to *Young Boy with Beret* (*pl. 35*), *L'Arlésienne* (*pl. 63*), *La Mousmé* (*pl. 31*), *Portrait of a Girl against a Pink Background* (*pl. 27*), *The Zouave* (*pl 33*), and *Man with a Pipe* (*pl. 51*), which is a superb assertion of artistic autonomy in face of the implacable tormentors, mental illness and solitude. This was the period of the two *Cafés* (*pls. 38-9*), in which Van Gogh's expressionist symbolism reached its highest point of tension, the period of the still-lifes, Van Gogh's *Yellow Chair* (*pl. 48*) and *Gauguin's Arm Chair*, objects chosen as symbols of human life. But it was equally the time of *L'Anglois, Bridge at Arles,* (*pl. 22*), of the limpid happiness of the discovery of line painted in light, of this pleasing balance of rhythms. This was the moment of romantic abandon to life in the *Starry Night* (1888, *pl. 26*), and also the exultant and primitive *Sunflowers* (*pl. 34*), the discovery of yellow as symbol, yellow as sun, yellow as mystical annihilation.

Van Gogh sought a victory for which the price was life itself. The tension was to become so acute, the need to overcome his personal self, even his individuality as artist, so obsessive that only by succumbing to the annihilation of the self could his work become an existential act, and not an individual act (the individual must disappear at this point, at any price – and this cost Van Gogh his psychological stability and his life). All this was necessary before he could become a symbol of absolute universal significance, living purely for others (and this, for him, meant posterity). This did not imply the need for a 'masterpiece' in the traditional sense; he never used the words 'masterpiece' or 'posterity'. He was very conscious of the fragility of the structural systems of the modern world. The crisis of society at that moment can be understood in this sense: the concept of a 'masterpiece', as an indestructible monument, *monumentum aere perennius,* was part of a social and human order which had already vanished. The modern world lived from day to day, and was conscious of the precariousness of everything. The artist's duty was to express this awareness, to seize on and translate the ineffable beauty of fragility. Universal cataclysms were at hand, and the new century, with its overthrow of established order, not far off.

And so Van Gogh tackled the chaos of the planets in the great, uneasy spirals of the second *Starry Night* (June 1889, *pl. 55*), in the seismic trembling of his olive groves (*pl. 57*), in the fluctuating, restless areas of colour that surround his last *Self-Portrait* (May 1890, *pl. 65*). (People have sought for a psychopathological explanation for this wavy, intricately woven pattern of blue-green lines, though it is also certain that the exponents of Art Nouveau saw in it something quite different, perhaps even the intuition of a new language devoted to the idea.)

He returned to the expressionist forms of his Dutch period (*Brick Cottages at Chaponval, pl. 79; Cottages at Cordeville, pl. 71*). There was also his admirable *Church at Auvers* (*pl. 75*), a compact mass, contracted into lines which compulsively break and bend in violent tension against a sky of indifferent concrete. But there was also evidence of a more formal serenity (*The Plain of Auvers, pls. 77-8;* the *Portrait of Mlle Gachet; Mlle Gachet in the Garden, pl. 70*) and, as a tragic end to a life of suffering, the two large canvases of the *Field in a Storm,* and *Cornfield with Rooks* (*pls. 82-3*), with its strange reversal of orthodox perspective, the vanishing-point being in the foreground.

Van Gogh and the Critics

'He was, almost always, a symbolist. Not, of course, a symbolist in the manner of the Italian primitives, mystics who hardly felt the need to materialize their dreams, but a symbolist who continually saw the necessity of translating his ideas into precise, appreciable and tangible form, intensely carnal and material. In almost all of his canvases, under this morphological disguise, in the shape of this supremely flesh-like flesh, and very material substance, is concealed for the person who knows how to look for it, a thought, an idea; it is precisely this Idea that is the essence of the work and both its efficient and final cause. As for the brilliant and dazzling symphonies of colour and line, whatever their importance may be for the painter, they are merely means towards expression, processes of *symbolization...* ' (from G.

Albert Aurier's article 'Les Isolés' in the *Mercure de France,* January 1890). This was the only article about Van Gogh to appear during his lifetime. Aurier went on to define symbolism in painting in a later number of the same review: 'A work of art should be: 1. idealistic; 2. symbolical; 3. synthetic; 4. subjective; 5. decorative.'

'*Dear Monsieur Aurier,*

'Many thanks for your article in the *Mercure de France,* which greatly surprised me. I like it very much as a work of art in itself, in my opinion your words produce colour, in short, I rediscover my canvases in your article, but better than they are, richer, more full of meaning. However, I feel uneasy in my mind when I reflect that what you say is due to others rather than to myself. For example, Monticelli in particular; ...as far as I know, there is no colourist who is descended so straightly and directly from Delacroix...

'Gauguin, that curious artist, that alien whose mien and the look in his eyes vaguely remind one of Rembrandt's *Portrait of a Man* in the Galerie Lacaze – this friend of mine likes to make one feel that a good picture is equivalent to a good deed; not that he says so, but it is difficult to be on intimate terms with him without being aware of a certain moral responsibility...

'And in conclusion, I declare that I do not understand why *you* should speak of Meissonier's 'infamies'. It is possible that I have inherited from the excellent Mauve an absolutely unlimited admiration for Meissonier; Mauve's eulogies on Troyon and Meissonier used to be inexhaustible – a strange pair...' (letter to M. Aurier no. 626a).

'At the Salon des Indépendants, among a few successful attempts and above all among a good deal of banality and farcical jokes, can be distinguished canvases by the lamented Van Gogh... Van Gogh possessed, to an exceptional degree, the quality which distinguishes one man from the next: style... Every brush stroke of this strange and potent being is lit up by an ulterior light, quite independent of the subject he is painting, and which is *in* him, and *of* him. He completely absorbs himself into each of his trees, his skies, flowers and fields, which he brings to life with the astonishing vitality of his nature. These forms multiply, unravel

and twist themselves, even in the admirable folly of his skies, where grotesque stars eddy and whirl, where planets are stretched out into oscillating comet's tails, until fantastic flowers are born which rear their heads and then shrivel up, like mad birds; even in this Van Gogh gives evidence of his admirable quality as a painter, as well as his frightening tragic grandeur.' (Octave Mirbeau, in *L'Echo de Paris*, 31 March 1891).

'I had not seen either a museum or an exhibition for twenty years... it took me a moment to orientate myself, to take in the unity of the canvases that I was looking at, to learn to make out the picture. But then I saw, I saw each of them separately and together, and understood both their interpretation of nature and the force of the human mind which knew how to mould it, and painted trees and bushes, fields and hillsides... Passing from one painting to the next, I could feel what linked them together, an interior life that flooded both into the colours and their relations; I could see them all living for each other, and there was always one mysteriously forceful one which supported all the others... P.S. The painter is called Vincent van Gogh. Judging by the fairly recent dates in the catalogue he must still be alive. Something obliges me to think that he belongs to my generation, and that he is no older than I am...' (Hugo von Hofmannsthal, letter of 1901).

These are some opinions by contemporaries of Van Gogh. But to speak of the critical verdict on Van Gogh is rather like discussing views about modern art. The reputation of a modern artist is always difficult to build up, and once achieved, just a year after his death, immediately perverted and distorted by a scheming commercial publicity machine. Thus it is often a prey to snobbery, and fashionable literary or pseudo-literary explanations, when it is not being treated as a pretext for drawing-room pseudo-scientific disquisitions such as *La mutilation sacrificielle et l'oreille coupée de Vincent van Gogh* (Bataille, 1930), or else *Psychoanalyse de Vincent van Gogh* (Aigrisse, in *Het cahier-de nevelvlek*, Antwerp, May-June 1955). (According to this theory, Van Gogh's picture of the *Prison Courtyard* is a surprising example of his desire to return to the maternal womb, while

being at the same time an attempt at escape by identifying himself with the sun, perfect symbol of his father...)

On the other hand, when it comes to Van Gogh's place in relation to the artistic movements that came after him, there is no doubt that the Nabis, the fauves, post-impressionism, Art Nouveau, and above all expressionism, all underwent his influence. The rigid symbolism of his ideas already contains the seeds of the break with figuration carried out by the abstract movements.

For their share in the critical reappraisal of Van Gogh's works the following texts deserve a mention: R. Huyghe, *Van Gogh*, Paris 1939; M. Seuphor, *Van Gogh*, Marseilles 1943; A. Parronchi, *Van Gogh*, Milan-New York 1944-53; L. Hautecoeur, *Van Gogh*, Munich 1946; A. M. Hammacher, *Van Gogh*, Deventer 1949; M. Shapiro, *Van Gogh*, New York 1950; V. Leclerc, *Van Gogh*, Paris 1950; J. Leymarie, *Van Gogh*, Paris 1951; M. Valsecchi, *Van Gogh*, Florence 1952; L. Vitali, *Van Gogh*, Milan 1966; Estienne, *Van Gogh,* Geneva 1953; M. De Micheli, *Van Gogh,* Milan 1952; and monographs by F. Arcangeli, *L'alfabeto di Van Gogh,* Florence 1942, and H. C. L. Jaffé, *L'apporto di Van Gogh alla critica d'arte,* Rome 1956. In English: F. Elgar, *Van Gogh,* London, 1966 and M. E. Tralbaut, *Van Gogh, a pictorial biography,* London, 1959. For general reference: H. Focillon, *La peinture au XIXe et XXe siecle*, Paris 1928; P. Francastel, *Nouveau dessin, nouvelle peinture,* Paris 1946; G. Bazin, *L'Epoque impressioniste,* Paris 1959; L. Venturi, *De Manet à Lautrec,* Paris 1953; J. Rewald, *Le Post-impressionisme,* Paris 1961; N. Ponente, *Le strutture dell'arte moderna,* Lausanne 1955. The quotation from G. C. Argan's text is drawn from the final report of the thirteenth Convegno Internazionale di Verucchio: *Artisti, Critici and Studiosi d'arte*, 1964.

Van Gogh's letters have been published in three volumes (New York Graphic Society, New York 1958 and Thames and Hudson, London 1958).

Notes on the Plates

1 The Beach at Scheveningen, 1882. The Hague period. Oil on cardboard, 34.5 × 51 cm. Ribbius Pelletier coll., Utrecht, formerly Oldenzeel gallery coll., Rotterdam. 'All during the week we have had a great deal of wind, storm and rain, and I went to Scheveningen several times to see it. I brought two small seascapes home from there. One of them is slightly sprinkled with sand - but the second, made during a real storm, during which the sea came quite close to the dunes, was so covered with a thick layer of sand that I was obliged to scrape it off twice. The wind blew so hard that I could scarcely stay on my feet, and could hardly see for the sand that was flying around. However, I tried to get it fixed by going to a little inn behind the dunes, and there scraped it off and immediately painted it in again, returning to the beach now and then for a fresh impression.' (Letter to Theo, no. 226). This canvas belongs to the period when the artist, having left the presbytery of Etten, was working at The Hague. While still linked to the classical forms of Dutch tradition, this canvas already reveals the artist's interest in the direct observation of spatial values and the vibrations of light. The composition is clearly that of classical Dutch landscapes, and the line of the horizon divides the picture almost in half.

2 Among the Dunes, 1883. The Hague period. Oil on panel, 33.5 × 48.5 cm. Mme A. M. Sythoff coll., Burgenhout, Wassenaar, Holland. Formerly Oldenzeel gallery coll., Rotterdam.

3 The Old Station at Eindhoven, ? 1884. Nuenen period. M. H. Korting coll., Gilze, Holland. This was the period of 'black painting', characterized by scenes of the daily lives of peasants and weavers. The memory of his apostolate to Borinage is still vivid. Clear relations of light and shadows. Remarkable synthesis of the different figurative elements. The colours are still spread on in large flatly-painted areas.

4 Woman Gleaning, 1885. Nuenen period. Charcoal and water colours on vellum, 52.5 × 43.5 cm. Rijksmuseum Kröller - Müller, Otterlo. One of the many drawings of peasants from the Dutch period. Illustrates his concern for the exact rendering of movement.

5 Peasant Woman with Moss-green Shawl, 1885. Nuenen period. Oil, 45 × 35 cm. Lyons, Musée des Beaux Arts. Former owners: L. C. Enthoven coll., Voorburg (sold by Fréderic Müller and Co. Amsterdam 10 May 1920); Le Fauconnier coll., Paris.
This belongs, together with *pl. 6*, to the collection of works and studies centred around the large picture of *The Potato-eaters* (see *pls. 7-8*). In the perceptive psychological rendering of the subject,

as in the free play of planes and shadows, there is a direct link with Franz Hals, though an awareness of contemporary ideas can also be sensed. Zola's *Germinal* strongly influenced Van Gogh's state of mind and his way of seeing things.

6 Peasant Woman with Red Beret, 1885. Nuenen period. Oil on panel, 38.5 × 26.5 cm. (detail). Musée du Jeu de Paume, Paris. Formerly F. W. Wentges coll., The Hague.
Dark palette, as in *pl. 5*. Realism intensifies the expression in a manner bordering on the grotesque. Van Gogh refused to listen to his brother Theo, who from Paris advised him to follow the impressionists and use clear tones. Instead, feeling himself supported by his chosen masters Delacroix, Millet and Israëls, he used dark earthy colours and distinct tonal contrasts.

7-8 The Potato-eaters, 1885. Nuenen period. Oil, 82 × 114 cm. V. W. van Gogh coll., Amsterdam. Formerly J. van Gogh-Bonger coll., Amsterdam.
There exists a copy of this picture, or perhaps a study for it, in the Rijksmuseum Kröller-Müller, Otterlo, a small study in oils, a lithograph, also in the Kröller-Müller Museum, two pen drawings, and a sketch in letter no. 399 to this brother. Five years later, during his stay at Saint-Rémy, Van Gogh again took up several variations of the same theme.
' Though the ultimate picture will have been painted in a relatively short time and for the greater part from memory, it has taken a whole winter of painting studies of heads and hands.
' And as to those few days in which I have painted it now, it has been a real battle, but one for which I feel great enthusiasm. Although I was repeatedly afraid I should never pull it off. But painting is also *agir-créer*...
' I have tried to emphasize that those people, eating their potatoes in the lamp-light, have dug the earth with those very hands they put in the dish, and so it speaks of *manual labour*, and how they have honestly earned their food.' (letter to Theo no. 404, 20 April 1885). Considered to be the apogee of Van Gogh's work of that period, this canvas is the most intense expression of his ' realist phase '. His ties with the Dutch school and Franz Hals are very evident. In the sombre scene are some remarkable pieces of painting: the coffee cups, the large and gnarled hands and the intense expressions. Peculiar is the positioning of the figures around the table, and equally the break in the central perspective made by the vertical wall on the right.

9 Group of Old Houses, 1885. Antwerp period. Oil on cardboard, 35 × 25 cm. M. L. C. Smit Kilnderdijk coll., Holland. Former owners: Oldenzeel gallery, Rotterdam (sold by A. Mak Amsterdam, 10 February 1919); Jan Smit coll., Alblasterdam; L. J. Smit coll., Kinderdijk, Holland. Though still sombre in tone, this canvas already shows the influence of Japanese art, in its treatment of perspective, which Van Gogh discovered at Antwerp.

10 Flowers, ? 1886. Paris period. Oil 73 × 34 cm. Baron G. H. Loudon coll., Aenderhout, Holland. Formerly V. W. van Gogh coll., Amsterdam.

11 Moulin de la Galette seen from the Rue Girardon, ? 1886. Paris period. Oil, 38 × 46.5 cm. Berlin, Staatliche Museen. Former owners: Galerie A. Vollard, Paris; Galerie Bernheim-Jeune, Paris; Orosdi coll., Paris; L. Nardus coll., Suresnes, (sold by Frédéric Müller & ' Co. Amsterdam 19 June 1917); M. H. Songet coll., Bussum; A. P. Nielsen coll., Amsterdam; Galerie A. Gold, Berlin.

12 Reclining Nude, ? 1886. Paris period. Oil, 39 × 61 cm. Mme L. Reinach-Goujon coll., Paris, since 1909. Former owners: Prince de Wagram coll., Paris; Drouet Gallery, Paris, 1908.

13 ' Japonaiserie ': The Tree, 1886. Paris period. Oil, 55 × 46 cm. Stedelijk Museum, Amsterdam. Formerly in Mme J. van Gogh-Bonger coll., Amsterdam; V. W. van Gogh coll., Amsterdam.
' Come now, isn't it almost a true religion which these simple Japanese teach us, who live in nature as though they themselves were flowers?
' And you cannot study Japanese art, it seems to me, without becoming much gayer and happier, and we must return to nature in spite of our education and our work in a world of convention...
' I envy the Japanese the extreme clearness which everything has in their work. It is never tedious, and never seems to be done too hurriedly. Their work is as simple as breathing, and they do a figure in a few sure strokes with the same ease as if it were as simple as buttoning your coat.
' Oh! Someday I must manage to do a figure in a few strokes. That will keep me busy all winter. Once I can do that, I shall be able to do people strolling on the boulevards, in the street, and heaps of new subjects. While I have been writing this letter I have drawn about a dozen. I am on the track of it, but it is very complicated because what I am after is that in a few strokes the figure of a man, a woman, a child, a horse, a dog, shall have a head, a body, legs, all in the right proportion. ' (letter to Theo, no. 542).

14 Père Tanguy, 1887. Paris period. Oil, 92 × 73 cm. Musée Rodin, Paris. Former owners: the sitter's daughter; Auguste Rodin coll., Paris.
A copy of the same subject, done at the same time (now in the Stavros Niarchos coll., New York), and a drawing (V. W. van Gogh coll.), accentuate the difference between the realism of the portrait and the abstract quality of the Japanese sketches in the background. In this version the relation between the two is more subdued, and the picture of Père Tanguy, one of the most cordial people Van Gogh met while he was in Paris, collector and friend of artists, is rendered with an almost calligraphic delicacy of line. The idea of a portrait incorporating works of art was then common among the intellectuals.

15 Gardens on the Butte Montmartre, 1887. Paris period. Oil, 96 × 120 cm. Stedelijk Museum, Amsterdam, formerly in J. van Gogh-Bonger coll., Amsterdam.

For this Van Gogh used the clear and limpid colours, the light rendered by chromatic division, and the suppressions of surroundings and chiaroscuro, which he borrowed from the impressionists. Traditional perspective has already been distorted in the expansion of the foreground, and in the dynamic flow of disconnected brush strokes.

16 Self-portrait, c. 1887. Paris period. Oil, 44 × 37.5 cm. V. W. van Gogh coll., Amsterdam.

While in Paris, Van Gogh painted more than twenty portraits. His study of the human face was always dominant, even though its realistic character gradually gave way to symbolical transfiguration, tending towards a closer portrayal of the subjects' hidden nature. This self portrait shows how Van Gogh interpreted the divisionist theories, and illustrates his already expressionist use of colour. The brushstrokes spreading outwards in a circle around the head give an impression of space bathed in light, and so intensify the symbolic significance.

17 The Bar, c. 1887. Paris period. Oil, 50 × 85 cm. Musée du Jeu de Paume, Paris. Former owners: Galerie Bernheim-Jeune, Paris, 1908; Galerie Drouet, Paris, 1909; Pierre Goujon coll., Paris; Musée du Luxembourg, Paris, (P. Goujon bequest).

18 Restaurant de la Sirène at Joinville, 1887. Paris period. Oil, 57 × 68 cm. Musée du Jeu de Paume, Paris, since 1921. Former owners: J. van Gogh-Bonger coll., Amsterdam; Amédée Schuffenecker coll., Clamart; Salomon Reinach coll., Paris.

19 Self-portrait, 1888. Paris period. Oil, 65 × 50.5 cm. Amsterdam, Stedeljik Museum, on loan since 1909. J. van Gogh-Bonger coll., Amsterdam.

This is the last of the Paris self-portraits, and represents a sort of synthesis of his studies on light. The contrast between light and shade, equally evident in the treatment of the face, symbolizes an inner conflict. The harmonies of the colours are arranged in a totally abstract and imaginary manner. The converging lines of the frame, the easel and the palette draw attention to the circular coloured lines of the face.

20 Pear-tree in Blossom, 1888. Arles period. Oil 73 × 46 cm. V. W. van Gogh coll., Amsterdam

' The little pear tree has a violet trunk and white flowers, with a big yellow butterfly on one of the clusters. To the left in the corner, a little garden with a fence of yellow reeds, and green bushes, and a flower bed. A little pink house.' (letter to Theo, no. 477, April 1888). With his contact with the southern countryside, the light and the spring which evoked for him his dream picture of a completely

idealized Japan, Van Gogh's painted world became clearer and pleasingly lighter. The picture becomes a pretext for a light and sensitive tracing, while the space is completely reinvented, in a reversal of the perspective planes. The background is lifted so as to become almost on a level with one's glance, while the foreground is expanded. Here too one senses the influence of Japanese prints.

21 Cornfield, ? 1888. Paris period. Oil, 54 × 64.5 cm. (detail). V. W. van Gogh coll. Amsterdam. Formerly J. van Gogh-Bonger coll., Amsterdam.
Executed in the impressionist style, with a feeling of total immersion in nature that was to be characteristic of his Arles experience. The composition of the picture is still that of traditional Dutch landscapes.

22 L'Anglois, Bridge at Arles, 1888. Arles period. Oil, 54.5 × 64 cm. Rijksmuseum Kröller-Müller, Otterlo. Former owners: J. van Gogh-Bonger coll., Amsterdam, (sold by Frédéric Müller & Co. Amsterdam, 21-22 May 1912); C. Hoogendijk coll., The Hague.
' I brought back a size 15 canvas today. It is a drawbridge with a little cart going over it, outlined against a blue sky - the river blue as well, the banks orange coloured with green grass and a group of women washing linen in smocks and multicoloured caps. And another landscape with a little country bridge and more women washing linen...
' I made my last three studies with the perspective frame I told you about. I attach some importance to the use of the frame because it seems not unlikely to me that in the near future many artists will make use of it, just as the old German and Italian painters certainly did, and, as I am inclined to think, the Flemish too. The modern use of it may differ from the ancient practice, but in the same way isn't it true that in the process of painting in oils one gets very different effects today from those of the men who invented the process, Jan and Hubert van Eyck? and the moral of this is that it's my constant hope that I am not working for myself alone. I believe in the absolute necessity of a new art of colour, of design, and – of the artistic life.' (letter to Theo, no. 469, March 1888). On several occasions the artist was to return to this scene of the bridge with few alterations. He was attracted by the gentle line of the horizon softened by the curve of the bridge, done in outline, which reminded him of Japan. This was the period of his discovery of the crystalline light of the south, a world of dreams.

23 The Drawbridge, 1888. Arles period. Oil, 50 × 65 cm. Wallraf-Richartz Museum, Cologne, since 1911. Former owners: Galerie Bernheim-Jeune, Paris; Galerie Flechtheim, Düsseldorf.
' I have done two new studies, a bridge and the side of a high road. Many subjects here are exactly like Holland in character, the difference is in the colour. There is that sulphur-yellow everywhere the sun lights.' (letter to Theo, no. 448, May 1888). Last version of a much repeated theme. The clear colours, in flatly painted areas recall his totally imaginary vision of the East. The harmony and

the proportions of the lines, all gently curved except for the diagonals of the foreground and the two diagonal cross beams of the little bridge, accentuate the impression of line drawing.

24 Garden in Flower at Arles, 1888. Arles period. Oil, 95 × 73 cm. Private coll., Zurich. Former owners: J. van Gogh-Bonger coll., Amsterdam; Dr. Gustav Schiefler coll., Mellingstedt; Dr Max Emden, Hamburg.
Even in this admirable and immediate scene of nature (July 1888) the perspective is entirely arbitrary, and the background overturned towards the top so as to accentuate the impression of direct absorption into the very heart of nature. One cannot fail to see in it a disconcerting foreshadowing of certain of the experiences of material naturalism which are parallel to and coincide with very recent informal discoveries, chiefly Italian.

25-6 Starry Night, 1888. Arles period. Oil, 75.5 × 92 cm. F. Moch coll., Paris. Former owners: J. van Gogh-Bonger coll., Amsterdam, (sold by Frédéric Müller & Co., Amsterdam, 20 June 1922); Bas-Veth coll., Bussum; Buffa Gallery, Amsterdam.
' Enclosed a little sketch of a square size 30 canvas, the starry sky actually painted at night under a gas jet. The sky is greenish-blue, the water royal blue, the ground mauve. The town is blue and violet, the gas is yellow and the reflections are russet-gold down to greenish-bronze. On the blue-green expanse of sky the Great Bear sparkles green and pink, its discreet pallor contrasts with the harsh gold of the gas.
' Two colourful little figures of lovers in the foreground.
' And it does me good to do difficult things. That does not prevent me from having a terrible need of - shall I say the word? - of religion. Then I go out at night to paint the stars. ' (letter to Theo, no. 543, September 1888). The theme of the starry night is a symbol of a cosmic vision of the real, in which all things are exalted in a state of tension which found its acme in the *Starry Night* of Saint-Rémy, in 1889 (see *pl. 55*), in a lucid exultation which involves the entire universe in a despairing whirl of planets in the solitude of the cosmos. There is a romantic gentleness in this picture, and an unaccustomed tranquillity which seem to indicate a rare moment of illusory happiness.

27 Portrait of a Young Girl against a Pink Background, 1888.
Arles period. Oil, 50 × 49 cm. Rijksmuseum Kröller-Müller, Otterlo.
' I must go to work. I saw another quite quiet and lovely thing the other day, a girl with a coffee-tinted skin, if I remember correctly, ash-blond hair, grey eyes, a print bodice of pale pink under which you could see the breasts, shapely, firm and small. ' (letter to Theo, no. 521).

28 Sailing Boats on the Beach at Les Saintes Maries, 1888.
Arles period. Oil, 64.5 × 81 cm. V. W. van Gogh coll., Amsterdam.
' About this staying on in the South, even if it is more expensive,

consider: we like Japanese painting, we have felt its influence, all the impressionists have that in common; then why not go to Japan, that is to say to the equivalent of Japan, the South?' (letter to Theo, no. 500, June 1888). This painting, entirely invented as far as the colours are concerned, remains one of the happiest of the artist's, precisely for its quality of clarity and harmony. The positioning of the boats was typical of Van Gogh, even in the drawings of his Dutch period; a drawing exists of this same theme with the names of colours marked down, a sketch in his letters, and a very beautiful water colour of immediate impact.

29-30 Market Gardens (The Blue Cart), 1888. Arles period. Oil, 72.5 × 92 cm. V. W. van Gogh coll., Amsterdam. Formerly J. van Gogh-Bonger coll., Amsterdam.
' I am working on a new subject, fields green and yellow as far as the eye can reach. I have already drawn it twice, and I am starting it again as a painting; it is exactly like a Salomon Konink - you know, the pupil of Rembrandt who painted vast plains. Or it is like Michel, or like Jules Dupré - but anyway it is very different from rose gardens. It is true that I have only been through one part of Provence, and that in the other part there is the kind of scenery that you get in Claude Monet, for instance.' (letter to Theo, no. 496, June 1888). Van Gogh was concluding his Parisian cultural experiences, which he translated in an explosion of luminous colour and distinct brushstrokes. The sunny countryside of Provence was for him a symbol of a new cosmic pantheism.

31 La Mousmé, 1888. Arles period. Oil, 74 × 60 cm.. Washington Gallery, New York, (Chester Dale Collection loan). Former owners: J. van Gogh-Bonger coll., Amsterdam; Galerie Bernheim-Jeune, Paris; C. M. van Gogh coll., Amsterdam; Carl Sternheim coll., La Hulpe; Galerie Hessel, Paris; Galerie Paul Rosenberg, Paris; Alphonse Kann coll., Saint-Germain-en-Laye; J. B. Stang coll., Oslo; Chester Dale coll., New York, since 1942.
' And, if you know what a *mousmé* is (you will know when you have read Loti's *Madame Chrysanthème*), I have just painted one... A *mousmé* is a Japanese girl - Provençal in this case - 12 to 14 years old.' (letter to Theo, no. 514, July 1888). ' I have just finished a portrait of a girl of twelve, brown eyes, black hair and eyebrows, grey-yellow flesh, the background heavily tinged with malachite green, the bodice blood red with violet stripes, the skirt blue with large orange polka dots, an oleander flower in the charming little hand. It has exhausted me so much that I am hardly in a mood for writing.' (letter to E. Bernard, no. B. 12, July 1888).
A very sensitive portrait in which Van Gogh, with his newly found awareness of pure colour and violent contrasts, tries to put into practice the suggestions of Japanese prints, with their blended colours.

32 The Postman Roulin, 1888. Arles period. Oil, 79.5 × 63.5 cm. Museum of Fine Arts, Boston. Former owners: (sold by Frédéric

Müller & Co., Amsterdam, 21-22 May, 1912); C. Hoogendijk coll., The Hague; Galerie Bernheim-Jeune, Paris; Galerie Paul Cassirer, Berlin; (sold by Frédéric Müller & Co, Amsterdam, 11 February 1919); Thea Sternheim coll., Uttwil; Robert Treat Paine coll., Boston.
'Last week I did not only one but two portraits of my postman, a half length with the hands, and a head, life size. The good fellow, as he would not accept money, cost *more* eating and drinking with me, and I gave him Rochefort's 'The Lantern' besides. But that is a trifling evil, considering that he posed very well and that I expect to paint his baby very shortly, for his wife has just had a child.' (letter to Theo, no. 518. August 1888).
'I have just done a portrait of a postman, or rather even two portraits. A Socratic type, none the less Socratic for being addicted to liquor and having a high color as a result. His wife had just had a child, and the fellow was aglow with satisfaction. He is a terrible republican, like old Tanguy. God damn it! what a motif to paint in the manner of Daumier, eh!' (letter to F. Bernard, no. B14, August 1888). In this canvas the study of the clear-cut relations between the colours can be interpreted in a psychological sense, a way of conveying this man's character which was entirely sympathetic to the artist in its simplicity and warm honesty. It was one of the first times when Van Gogh used a distinct black line for certain parts of the clothes; this spreads out into shadows in a sort of *cloisonnisme* reminiscent of Gauguin.

33 The Zouave, 1888. Arles period. Oil, 81 × 65 cm. Albert D. Lasker coll., New York. Former owners: Prince de Wagram coll., Paris; Galerie Drouet, Paris, from November 1908; Galerie Flechtheim, Berlin, from October 1912; Galerie Tanner, Zurich; Galerie Paul Vallotton, Lausanne; Eisenloeffel gallery, Amsterdam; Unger & van Mens gallery, Rotterdam; Galerie A. van Hoboken, Vienna.
'I have a model at last - a Zouave - a boy with a small face, a bull neck, and the eye of a tiger, and I began with one portrait, and began again with another; the half-length I did of him was horribly harsh, in a blue uniform, the blue of enamel saucepans, with braids of a faded reddish-orange, and two stars on his breast, an ordinary blue and very hard to do. That bronzed, feline head of his with the reddish cap, against a green door and the orange bricks of a wall. So it's a savage combination of incongruous tones, not easy to manage. The study I made of it seems to me very harsh, but all the same I'd like always to be working on vulgar, even loud portraits like this. It teaches me something, and above all that is what I want of my work.' (letter to Theo, no. 501, August 1888).
This is an original piece of work, both in its colours and for its construction of opposing symmetries.

34 Sunflowers, 1888. Arles period. Oil, 91 × 72 cm. Neue Staatsgalerie, Munich (gift of an art lover in memory of H. von Tschudi), since 1912.

'I am hard at it, painting with the enthusiasm of a Marseillais eating bouillabaisse, which won't surprise you when you know that what I'm at is the painting of some big sunflowers.

'I have three canvases going - 1st, three huge flowers in a green vase, with a light background, a size 15 canvas; 2nd, three flowers, one gone to seed, having lost its petals, and one a bud against a royal-blue background, size 25 canvas; 3rd, twelve flowers and buds in a yellow vase (size 30 canvas). The last one is therefore light on light, and I hope it will be the best. Probably I shall not stop at that. Now that I hope to live with Gauguin in a studio of our own, I want to make decorations for the studio. Nothing but big flowers. Next door to your shop, in the restaurant, you know there is a lovely decoration of flowers; I always remember the big sunflowers in the window there.

'If I carry out this idea there will be a dozen panels. So the whole thing will be a symphony in blue and yellow. I am working at it every morning from sunrise on, for the flowers fade so soon, and the thing is to do the whole in one rush.' (letter to Theo, no. 526), August 1888). Van Gogh's passion for sunflowers foreshadows certain symbolic forms linked to the biological and moral ideas of the end of the nineteenth century, in which nature becomes the expression of aesthetic vitality. The theme of sunflowers (which the artist repeated in an infinite number of variations) is his hymn to the glory of living, symbolized in the sun. The colour is used emblematically.

35 Young Boy with Beret, 1888. Arles period. Oil, 47.5 × 39 cm. Dr. Fritz Nathan coll., Zurich. Former owners: G. F. Reber coll., Barmen; Thannhauser coll., Lucerne; K. Neumann coll., Barmen. The expressive immediacy of the features recalls, even though done with a different purpose in mind, the Dutch period. Here, however, realism is transformed into a psychological factor.

36 The Gypsies, 1888. Arles period. Oil, 45 × 51 cm. Musée du Jeu de Paume, Paris. Former owners: M. Fabre coll., Gasparets; Galerie Drouet, Paris, 1909; Galerie Rosenberg, Paris; Raymond Koechlin coll., Paris.

37 The Bush, 1888. Arles period. Oil, 73 × 92 cm. Hermitage, Leningrad. Former owners: Mme Leclerc coll., Paris; S. J. Shchukin coll., Moscow; Museum of Modern Art, Moscow.
This is an example of Van Gogh's symbolic naturalism. Nature, as an element of substance and colour, and as a cosmic symbol, takes over the picture in its entirety, in a pulsating atmosphere which was to become yet more intense in the *Field with little Yellow Flowers*, and in the *Corner of Meadow*, painted in the same year and in which the total surface of the canvas becomes an area of continuous vibrating strokes; one is reminded immediately of Tobey or Pollock.

38 All Night Café, 1888. Arles period. Oil, 70 × 89 cm. Stephen Clark coll., Yale University, USA. Former owners: J. van Gogh-

Bonger coll., Amsterdam; J. A. Morozov coll., Moscow (bought at the Exhibition of the Toison d'Or, Moscow 1908); Museum of Modern Art, Moscow; Private Collection, New York.

'The picture is one of ugliest I have done. It is the equivalent, though different, of "The Potato-eaters".

'I have tried to express the terrible passions of humanity by means of red and green.

'The room is blood red and dark yellow with a green billiard table in the middle; there are four citron-yellow lamps with a glow of orange and green. Everywhere there is a clash and contrast of the most disparate reds and greens in the figures of little sleeping hooligans, in the empty, dreary room, in violet and blue. The blood-red and the yellow-green of the billiard table, for instance, contrast with the soft tender Louise XV green of the counter, on which there is a pink nosegay. The white coat of the landlord, awake in a corner of that furnace, turns citron-yellow, or pale luminous green... It is colour not locally true from the point of view of the delusive realist, but colour suggesting some emotion of an ardent temperament.' (letter to Theo, no. 533, September 1888).

'I have tried to express the idea that the café is a place where one can ruin oneself, go mad or commit a crime. So I have tried to express, as it were, the powers of darkness in a low public house, by soft Louis XV green and malachite, contrasting with yellow-green and harsh blue-greens, and all this in an atmosphere like a devil's furnace, of pale sulphur.

'And all with an appearance of Japanese gaiety, and the good nature of Tartarin.' (letter to Theo, no. 534, September 1888). This is perhaps Van Gogh's most expressionist painting. The hallucinating atmosphere of abstract symbolism is intensified in the violent distortions of the perspective, and in the vibrating irradiation of the areas surrounding the shining lights, natural focal point of the artist's expressive world. (The café shown is now called the Café de l'Alcazar.)

39 Café Terrace at Night, 1888. Arles period. Oil, 79 × 63 cm. Rijksmuseum Kröller-Müller, Otterlo.

'The second represents the outside of a café, with the terrace lit up by a big gas lamp in the blue night, and a corner of a starry blue sky...

'The problem of painting night scenes and effects on the spot and actually by night interests me enormously.' (letter to Theo, no. 537, September 1888).

40 Self-portrait, 1888. Dedicated to Gauguin. Arles period. Oil, 62 × 52 cm. Fogg Art Museum, Harvard University, Cambridge, Mass., USA. Former owners: Paul Gauguin coll., Paris; Neue Staatsgalerie, Munich, from 1919; Maurice Wertheim coll., New York.

'The third picture this week is a portrait of myself, *almost colourless,* in gray tones against a background of pale malachite.' (letter to Theo, no. 537, September 1888).

41 Sunset, 1888. Arles period. Oil, 74 × 91 cm. Kunstmuseum, Winterthur (gift of M. Emil Hahnloser, Zurich). Former owners: sold by Frédéric Müller & Co. Amsterdam, 18 May 1920; L. C. Enthoven coll., Voorburg; Dr. Emil Hahnloser, Zurich.

'Here is yet another landscape; sunset or moon rising? In any case a summer sun. Violet town, yellow planet, blue-green sky. The wheat has all the tones of old gold, copper, green or red gold, bronze-yellow, green red... I painted it during a mistral with my easel planted into the ground with iron stakes 50 centimeters long. Everything was attached with rope. Like this, one can work in the wind.' (letter to E. Bernard, September 1888). As is usual in the landscapes of this period the line of the horizon is carried towards the top to redress the foreground. This is the characteristic distortion of Van Gogh's perspective, already used by Signac in *Andelys* to lend a larger surface to the play of luminous vibrations.

42 The Sower, 1888. Arles period. Oil, 73 × 92 cm. E. G. Bürhle coll., Zurich. Former owners: Mme Frédéric van Eedevan Vléter, Laren, Amsterdam; Aytretsch gallery, The Hague; Galerie Paul Cassirer, Berlin; Franz von Mendelssohn-Bartholdy coll., Grünewald.

'This is a sketch of the latest canvas I am working on, another Sower. An immense citron-yellow disc for the sun, a green-yellow sky with pink clouds. The field violet, the sower and the tree Prussian blue.' (letter to Theo, no. 558, October 1888). The movement of the sower, studied and worked on at length in a religious-social connotation by Millet, is transformed here into a symbol more openly pantheistic and cosmic, in a glorification of pure colour.

43 Les Alyscamps, 1888. Arles period. Oil, 72 × 91 cm. M. S. Niarchos collection, Athens. Former owners: J. van Gogh-Bonger coll., Amsterdam; Jos. Hessel coll., Paris; Adolf Beusinger coll., Mannheim.

'It is some poplar trunks in lilac cut by the frame where the leaves begin.

'These tree trunks are lined like pillars along an avenue where there are rows of old Roman tombs of a blue lilac right and left. And then the soil is covered with a thick carpet of yellow and orange fallen leaves. And they are still falling like flakes of snow.

'And in the avenue, little black figures of lovers. The upper part of the picture is a bright green meadow, and no sky, or almost none.' (letter to Theo, no. 559, November 1888).

This was the time of Gauguin's stay in Arles, of the communal work (a picture of the same subject of Gauguin's exists, with clearly demarcated zones, limpid colours, and already Nabi tone) and probably of the first signs of insanity. From the way in which the picture is cut up by the trunks (another version exists, different but with similar characteristics), one can guess at the artist's psychological sense of oppression, almost reclusion, aggravated by his conflict with Gauguin's domineering personality.

44 Portrait of Armand Roulin, 1888. Arles period. Oil, 65 × 54 cm. Folkwang Museum, Essen. Formerly Karl Osthaus coll., Hagen. 'But I have made portraits *of a whole family,* that of the postman, whose head I had done previously - the man, his wife, the baby, the little boy, and the son of sixteen, all characters and very French, though the first has the look of a Russian. Size 15 canvas. You know how I feel about this, how I feel in my element, and that it consoles me up to a certain point for not being a doctor. I hope to get on with this and to be able to get more careful posing, paid for by portraits. And if I manage to do this *whole family* better still, at least I shall have done something to my liking and something individual.' (letter to Theo, no. 560, November 1888).

45 Portrait of Armand Roulin, 1888. Arles period. Oil, 65 × 54 cm. Boymans-Van Beuningen Museum, Rotterdam. Former owners: Galerie Bernheim-Jeune, Paris; Galerie Goldschmidt, Frankfurt.

46 Promenade at Arles (Memories of the Garden at Etten), 1888. Arles period. Oil, 73 × 92 cm. (detail). Hermitage, Leningrad. Former owners: A. Schuffenecker coll., Clamart; S. J. Shchukin coll., Moscow; Gallery of Modern Art, Moscow.
Here as in the two preceding portraits, Van Gogh transfigures the human face by the linear representation of the whole.

47 L'Arlésienne (Mme Ginoux), 1888. Arles period. Oil, 90 × 72 cm. Metropolitan Museum of Art, New York (A. Lewisohn Bequest). Former owners: Bernt Grönvoldt coll., Berlin; Fritz Schön coll., Grünewald; Galerie Paul Cassirer, Berlin; S. Bourgeois Gallery, New York; A. Lewisohn coll., New York.
'Then I have an Arlésienne at last, a figure (size 30 canvas) slashed on in an hour, background pale citron, the face grey, the clothes black, black, black, with perfectly raw Prussian blue. She is leaning on a green table and seated in an armchair of orange wood.' (letter to Theo, no. 559, November 1888). Treated in the same way as a Japanese drawing with the flat profile engraved against a luminous background, this portrait is one of the best known in modern art, for its expressive strength, its intensity and the violence of its characterization.

48 The Yellow Chair, 1888-9. Arles period. Oil, 92.5 × 73.5 cm. National Gallery, London (Courtauld Bequest, 1924). Formerly J. van Gogh-Bonger coll., Amsterdam
'I should like De Haan to see a study of mine of a lighted candle and two novels (one yellow, the other pink) lying on an empty armchair (really Gauguin's chair), a size 30 canvas, in red and green. I have just been working again today on its pendant, my own empty chair, a white deal chair with a pipe and a tobacco pouch. In these two studies, as in others, I have tried for an effect of light by means of clear colour...' (letter to Theo, no. 571, 17 January 1889).

Together with his famous *Gauguin's Arm Chair*, this is one of the artist's most intense pieces, in the strength of its expressive significance of an object as a symbol of human life. The treatment of the planes, the slightly accelerated perspective, and the relations between the colours make this an example of lyrical expressionism.

49 La Berceuse (Mme Roulin), 1889. Arles period. Oil, 91 ×71.5 cm. V. W. van Gogh coll., Amsterdam. Formerly J. van Gogh-Bonger coll., Amsterdam.
' I think I have already told you that besides these I have a canvas of 'La Berceuse', the very one I was working on when my illness interrupted me. I now have two copies of this one too.
' I have just said to Gauguin about this picture that when he and I were talking about the fishermen of Iceland and of their mournful isolation, exposed to all dangers, alone on the sad sea - I have just said to Gauguin that following those intimate talks of ours the idea came to me to paint a picture in such a way that sailors, who are at once children and martyrs, seeing it in the cabin of their Icelandic fishing boat, would feel the old sense of being rocked come over them and remember their own lullabys.
' Now, it may be said that it is like a chromolithograph from a cheap shop. A woman in green with orange hair standing out against a background of green with pink flowers. Now these discordant sharps of crude pink, crude orange, and crude green are softened by flats of red and green.' (letter to Theo, no. 574, March-April 1889). Painted at the time of his strained relations with Gauguin, with reference to the romantic rather bourgeois literary ideal of an autodidact (Loti's *Les Pêcheurs d'Islande*). We know of at least four copies with very small alterations, and drawings.

50 Portrait of Dr Rey, 1889. Arles period. Oil, 64 × 53 cm. Museum of Modern Art (Pushkin), Moscow. Former owners: Galerie Cassierer, Berlin; Galerie Drouet, Paris, 1908; S. J. Shchukin coll., Moscow, from 1908.
After his stay in hospital following the insane act of severing his ear, Van Gogh returned to work with enthusiasm. Gauguin had left, and the violent and disturbing influence thus ceased. Particularly noticeable here is the intensity of expression.

51 Man with a Pipe (Portrait with Severed Ear), 1889. Arles period. Oil, 51 × 45 cm. (detail). M. and Mrs. Leigh B. Block coll., Chicago. Former owners: A Schuffenecker coll., Paris; G. Fayet coll., Igny, as from 1902; Galerie Paul Rosenberg, Paris.
This self-portrait, painted in January-February 1889, illustrates the new expressionist concept of colour, which was treated as a raw material and applied directly from the tube. As with *The Yellow Chair* (see *pl. 48*), and *Gauguin's Arm Chair*, the symbols (the bandaged head, the pipe) are arranged in a rigorously pictorial space.

52 Field of Irises, 1889. Saint-Rémy period. Oil, 71 × 93 cm. Mrs Charles Payson coll., New York. Former owners: Galerie

Tanguy, Paris; Octave Mirbeau coll., Paris, from 1892; Pellerin coll., Paris; Galerie Bernheim-Jeune, Paris; Mme Jacques Doucet coll., Neuilly-sur-Seine.
This is perhaps the first work painted in the Saint-Rémy lunatic asylum, and it shows a clarity of layout, an originality of the drawing, and a careful study of moving forms which is already a prelude to his later canvases in its variety of curvilinear, flame-like, unstable outlines. The whole canvas is a united pictorial scene, the entire surface treated as a foreground, and is extremely modern in composition.

53 Green Fields near Saint-Rémy, 1889. Saint-Rémy period. Oil, 73 ×92. Prague, Narodní Galerie. Former owners: Paul Rosenberg coll., Paris, from 1923; W. Halvorsen coll., Paris.
' I have a canvas of cypresses with some ears of wheat, some poppies, a blue sky like a piece of Scotch plaid; the former painted with a thik impasto like the Monticellis, and the wheat field in the sun, which represents the extreme heat, very thick too. ' (letter to Theo, no. 597, June 1889). Landscape bathed in colour, with the usual reversed perspective. See also *pl. 54.*

54 Yellow Wheat, 1889. Saint-Rémy period. Oil, 73 × 93 cm. Mendelsohn-Bartholdy coll., Grünewald. Former owners: Prince de Wagram, Paris; Galerie Barbazanges, Paris.

55 Starry Night, 1889. Saint-Rémy period. Oil, 73 × 92 cm. Museum of Modern Art, New York.. Former owners: G. P. van Stolk coll., Rotterdam; Galerie Paul Rosenberg, Paris.
' It is not a return to the romantic or to religious ideas, no. Nevertheless, by going the way of Delacroix, more than is apparent, by colour and a more spontaneous drawing than delusive precision, one could express the purer nature of a countryside compared with the suburbs and cabarets of Paris.
' One would try to paint human beings who are also more serene and pure than Daumier had before his eyes, but following Daumier, of course, in the drawing...
' Gauguin, Bernard and I may stop at that point perhaps and not conquer, but neither shall we be conquered; perhaps we exist neither for the one thing nor for the other, but to give consolation or to prepare the way for a painting that will give even greater consolation. ' (letter to Theo, no. 595, June 1889). In this picture, which is almost a cosmic synthesis of all of Van Gogh's human and visual studies, it is as if stars, earth and sky were revolving in a flaming atmosphere, prelude to the despairing solitude of the individual.

56 Evening Stroll, 1889. Saint-Rémy period. Oil, 49.5 × 45.5 cm. São Paolo, Museu. Former owners: J. van Gogh-Bonger coll., Amsterdam; A. G. Kröller coll., The Hauge; P. R. Bruckmann coll. The Hague, from 1910.

57 Olive Trees. Saint-Rémy period. Oil, 72.5 × 92 cm. John Hay Whitney coll., New York. Former owners: J. van Gogh-Bonger coll., Amsterdam; Karl Osthaus coll., Hagen; D. Compter gallery, Amsterdam; S. van Deventer coll. Wassenaar.
The entire landscape is pervaded by the artist's raging passion which breaks every rule of classical composition and intertwines all the lines of direction in one whirling dynamic mass, symbol of the artist's total absorption in the pure heart of nature, which becomes the means of translating the torments of human existence.

58 Meadows. Sait-Rémy period. Oil, 21.5 × 32.5 cm. H. P. Bremmer coll., The Hague. Former owners: Wilhelmine van Gogh coll., (the artist's sister); C. M. van Gogh Gallery, Amsterdam.

59 Hospital at Arles, 1889. Saint-Rémy period. Oil, 74 × 92 cm. Oscar Reinhart coll., Winterthur. Former owners: Rousseau coll., (secretary of Arles hospital); Nivière coll., (chemist in Arles); Galerie Barbazanges, Paris; Prince de Wagram coll., Paris; Alph. Kahn coll., Paris; Winkel & Magnussen gallery, Copenhagen; Galerie Hodebert, Paris.
' I have worked on a study of the mad ward at the Arles Hospital. ' (letter to Theo, no. 611, October 1889).

60 Van Gogh's Bedroom, 1889. Saint-Rémy period. Oil, 56.5×74 cm. Musée du Jeu de Paume, Paris, became property of the French state after the peace treaty with Japan. Former owners: Werner Dücker coll., Düsseldorf; Galerie Rosenberg, Paris; Prince Matsugata coll., Kobe, Japan.
This is a variation on his theme of 1888; he reapplied his symbolic-expressionist concept of internal space to it.

61 The Ravine (Les Péroulets), 1889. Saint - Rémy period. Oil, 73.5 × 92 cm. (detail). Rijksmuseum Kröller-Müller, Otterlo. Former owners: A. Schuffenecker coll., Paris; Galerie Barbazanges, Paris; Barnes coll., Merion; Prince de Wagram coll., Paris; Barbazanges coll., Paris; A. Schuffenecker coll., Paris; Graf Kessler coll., Berlin.
' I am working on a large canvas of a ' Ravine '; it is quite the same motif as your study with a yellow tree, which I still have; two bases of extremely solid rocks, between which there flows a rivulet; a third mountain blocking the ravine.
' Such subjects certainly have a fine melancholy, but then it is fun to work in rather wild places, where one has to dig one's easel in between the stones lest the wind should blow the whole caboodle over. ' (letter to E. Bernard, no. B. 20, October 1889).
Once again a violent expressionist rendering of the transference of human passions to nature.

62 The Schoolboy, 1890. Saint-Rémy period. Oil, 63.5 × 54 cm. São Paolo, Museu. Former owners: Galerie Thannhauser, Munich; Dr. K. Güttler coll., Reichenstein; Galerie Thannhauser, Munich; M. Meirowsky coll., Berlin.

.ven here the space is entirely invented, following a form of lynamics of colour relations which enhances the intense emotional content of the picture.

63 L'Arlésienne, 1890. (After Gauguin). Saint-Rémy period. Oil, 65 × 54 cm. São Paolo, Museu. Former owners: Bandy coll., Paris; Tilla Durieux-Cassirer, Berlin; Galerie O. Kallir-Nirenstein, Vienna; Oscar Federer coll., Moravska - Ostrava.
'And it gives me enormous pleasure when you say the Arlésienne's portrait, which was based strictly on your drawing, is to your liking. I tried to be religiously faithful to your drawing, while nevertheless taking the liberty of interpreting through the medium of colour, the sober character and the style of the drawing in question. It is a synthesis of the Arlésiennes, if you like; as syntheses of the Arlésiennes are rare, take this as a work belonging to you and me as a summary of our months of work together. For my part I paid for doing it with another month of illness, but I also know that it is a canvas which will be understood by you, and by a very few others, as we would wish it to be understood.' (letter to Gauguin, no. 643, February 1890). Painting in the style and with the colours of artists he admired or esteemed was a characteristic of all of Van Gogh's work. In the case of Gauguin, for whom he had a feeling of reverent admiration, even after the violent clash which largely precipitated his mental breakdown, Van Gogh developed a continuous reciprocal exchange of methods.

64 The White Roses, 1890. Saint-Rémy period. Oil, 93 × 72 cm. Mrs Albert D. Lasker coll., New York. Former owners: Galerie Cassirer, Berlin; Mme F. Oppenheim coll., Berlin; G. Hirschland coll., Essen.

65 Self-portrait, 1890. Auvers period. Oil, 65 × 54 cm. Musée du Jeu de Paume, Paris, (gift of Marguerite and Paul Gachet to the Louvre in 1949). Formerly Dr Paul Gachet coll., Auvers-sur-Oise. This is perhaps the finest of the self-portraits, as well as the most intense and the most tormented. The stirring turbulent background, an indication of the mental tension of the artist in the last period of his life, seems to have opened up new horizons in art. Nor did the exponents of Art Nouveau, among others, fail to pick up the signs: the emotional evocative power of these curved lines was to become a fundamental tenet of their language. This picture has a sense of proportion of relations and an insight rarely attained by Van Gogh.

66 Country Road by Night, 1890. Saint-Rémy period. Oil, 91×71 cm. Rijksmuseum Kröller-Müller, Otterlo. Former owners: A. Schuffenecker coll., Paris; G. Albert Aurier coll., Châteauroux.
'I still have a cypress with a star from down there, a last attempt – a night sky with a moon without radiance, the slender crescent barely emerging from the opaque shadow cast by the earth – one star with

an exaggerated brilliance, if you like, a soft brilliance of pink and green in the ultramarine sky, across which some clouds are hurrying. Below, a road bordered with tall yellow canes, behind these the blue *Basses Alpes*, an old inn with yellow lighted windows, and a very tall cypress, very straight, very sombre. On the road, a yellow cart with a white horse in harness, and two late wayfarers. Very romantic, if you like, but also *Provence,* I think.' (letter to Gauguin, no. 643, Summer 1890).

67 Portrait of Dr Gachet, 1890. Auvers period. Oil, 68 × 57 cm. Musée du Jeu de Paume, Paris, (gift of Marguerite and Paul Gachet to the Louvre in 1949). Formerly Dr Paul Gachet coll., Auvers-sur-Oise.
' I am working at his portrait, the head with a white cap, very fair, very light, the hands also a light flesh tint, a blue frock coat and a cobalt blue background, leaning on a red table, on which are a yellow book and a foxglove plant with purple flowers. It has the same sentiment as the self-portrait I did when I left for this place. M. Gachet is absolutely *fanatical* about that portrait, and wants me to do one for him, if I can, exactly like it. I should like to myself.' (Letter to Theo, no. 638, 4 June 1890). In fact a copy of this portrait, done at the same time, exists (from the S. Kramarsky coll., New York) and a water colour (Dr Gachet was teaching him the technique), but the tension and the rhythm of the picture are quite different.

68-9 Poppy Fields, 1890. Auvers period. Oil, 73 × 93 cm. The Hague Museum. Former owners: Prince de Wagram coll., Paris; E. Drouet Gallery, Paris, 1909; Galerie Barbazanges, Paris. Yet another example of ecstatic union with nature, expressed through colour.

70 Mlle Gachet in the Garden, 1890. Auvers period. Oil, 46×55 cm. Musée du Jeu de Paume, Paris (gift of Dr Paul Gachet). Formerly Dr Paul Gachet coll., Auvers-sur-Oise.
' ...and then last Sunday some white roses, vines, and a white figure standing in the middle.' (letter to Theo, no. 638, 4 June 1890).

71 Cottages at Cordeville (Moncel Cottages), 1890. Auvers period. Oil, 72 × 91 cm. Musée du Jeu de Paume, Paris (gift of Dr Paul Gachet in 1954). Formerly Dr Paul Gachet coll., Auvers-sur-Oise. In this extremely tense moment can be detected a strange regression to the themes of the Dutch period (there was also to be a new return to Millet) transposed, naturally, into his new, nervous style.

72 Peasant Girl in a Cornfield, 1890. Auvers period. Oil, 92×73 cm. Prof. H. R. Hahnloser coll., Berne. Former owners: Mme A. Müller-Abeken coll., Scheveningen, (sold by Fréderic Müller & Co Amsterdam); Dr A. Hahnloser coll., Winterthur.

'A peasant woman, big yellow hat with a knot of sky-blue ribbons, very red face, rich blue blouse with orange spots, background of ears of wheat. It is a size 30 canvas, but I'm afraid it's really a bit coarse.' (letter to Theo, no. 646, 30 June 1890).
Even here the attention paid to reality reminds one of his Dutch period.

73-4 Landscape near Auvers, 1890. Auvers period. Oil, 73.5×92 cm. Neue Pinakothek, Munich (on loan from Mme Hugo von Tschudi). Formerly J. van Gogh-Bonger coll., Amsterdam.
'I myself am quite absorbed in the immense plain with wheatfields against the hills, boundless as a sea, delicate yellow, delicate soft green, the delicate violet of a dug-up and weeded piece of soil, checkered at regular intervals with the green of flowering potato plants, everything under a sky of delicate blue, white, pink, violet tones. I am in a mood of almost too much calmness, in the mood to paint this.' (letter to his mother and sister, no. 650/r, July 1890).

75 Church at Auvers, 1890. Auvers period. Oil, 94 × 74 cm. Musée du Jeu de Paume, Paris (acquired by the Louvre from Dr Paul Gachet in 1951). Formerly Dr Paul Gachet coll., Auvers-sur-Oise.

76 Ears of Corn, 1890. Auvers period. Oil, 64.5 × 47 cm. Stedelijk Museum, Amsterdam. Former owners: J. van Gogh-Bonger coll., Amsterdam; V. W. van Gogh coll., Amsterdam.
'Look, here's an idea which may suit you, I am trying to do some studies of wheat like this, but I cannot draw it – nothing but ears of wheat with green-blue stalks, long leaves like ribbons of green shot with pink, ears that are just turning yellow, edged with the pale pink of the dusty bloom – a pink bindweed at the bottom twisted round a stem.
'After this I would like to paint some portraits against a very vivid yet tranquil background. There are the greens of a different quality, but of the same value, so as to form a whole of green tones, which by its vibration will make you think of the gentle rush of the ears swaying in the breeze; it is not at all easy as a colour scheme.' (letter to Gauguin, no. 643. Summer 1890).
This canvas is perhaps the culminating example of the definition 'flat surface covered with colour in a defined order' proposed by Maurice Denis and the Nabis, and opened the way for an interpretation of art as an end in itself, independent of the subject, which was exactly the aim of abstract naturalism.

77-8 The Plain of Auvers, 1890. Auvers period. Oil, 50×100 cm. Oesterreichische Staatsgalerie, Vienna (gift of the Society of Artists of the Austrian Secession). Formerly C. M. van Gogh Gallery, Amsterdam.
'I have noticed that this canvas goes very well with another horizontal one of wheat, as one canvas is vertical and in pink tones,

the other pale green and greenish-yellow, the complementary of pink; but we are still far from the time when people will understand the curious relation between one fragment of nature and another, which all the same explain each other and enhance each other.' (letter to Theo, no. 645, July 1890).

79 Miners' Houses, 1890 (Brick Cottages at Chaponval). Auvers period. Oil, 65 × 81 cm. Kunsthaus, Zurich (Dr Hans Schuler legacy). Formerly Dr Hans Schuler coll., Zurich.

80 Gardens behind the Houses, 1890. Auvers period. Charcoal, water colour, oil on cardboard, 43.5 × 54 cm. V. W. van Gogh coll., Amsterdam.

81 Dr Gachet's Garden, 1890. Auvers period. Oil, 73 × 51 cm. Musée du Jeu de Paume, Paris (gift of Dr Paul Gachet in 1954). Formerly Dr Paul Gachet coll., Auvers-sur-Oise.

82-3 Cornfield with Rooks, 1890. Auvers period. Oils, 50.5 × 105 cm. V. W. van Gogh coll., Amsterdam. Formerly J. van Gogh-Bonger coll., Amsterdam.
' There – once back here I set to work again – though the brush almost slipped from my fingers, but knowing exactly what I wanted, I have painted three more big canvases since. They are vast fields of wheat under troubled skies, and I did not need to go out of my way to try to express sadness and extreme loneliness.' (letter to Theo and his sister, no. 649, June 1890). This is the last and perhaps the best known of Van Gogh's works, painted almost on the eve of his suicide. In this famous canvas the peculiar format of the picture, the dilated perspective and the crossed directions all unite to create a sense of extraordinary unease, enhanced by the confused superimposition of colour, a technique hardly ever used by the artist. Instead of leading to the horizon, the lines converge into the foreground with disconcerting aggressiveness.

84 Breton Women, 1888. (After Emile Bernard). Arles period. Water colour, gouache and charcoal (detail). Owner unknown. This is one of the examples of a loan of subject and forms from another painter, used by Van Gogh as if to test his own powers of characterization, on predetermined elements. Particularly noticeable is the *cloisonné*, also used by Bernard, but with much less strength and justification than Gauguin, for example.

85 Boy Tying Sheaves, 1889. (After Millet) Saint-Rémy period. Oil, 44 × 32.5 cm. Stedelijk Museum, Amsterdam (in trust). V. W. van Gogh coll., Amsterdam.
' Once you get them [the copies] you will see clearly that they have been done out of a profound and sincere admiration for Millet. Then, whether they are someday criticized or despised as copies, it will nonetheless be true that they have their justification in the attempt

to make Millet's work more accessible to the great general public.'
(letter to Theo, no. 623, January 1890).

86 Pietà, 1889. (After Delacroix). Saint-Rémy period. Oil, 73×60.5 cm. V. W. van Gogh coll., Amsterdam. A small copy with several alterations exists of this picture, done at Auvers in 1890. This was the time when Van Gogh, shut up in the Saint-Rémy hospital, was reviewing and evaluating all his past life.

87 Prisoners at Exercise, 1890. (After a print in the book *Londres*, 1872, illustrated by Gustave Doré). Saint-Rémy period. Oil, 80 × 64 cm. Museum of Modern Art (Pushkin), Moscow. Former owners: J. van Gogh-Bonger coll., Amsterdam; Mme M. Slavona coll., Paris; M. Fabre coll., Paris; E. Drouet coll., Paris, 1906; Prince de Wagram coll., Paris, 1909; Galerie Drouet, Paris; J. A. Morozov coll., Moscow, from 1909. Evocative transcription of a print by Doré, full of mysterious and disturbing psychological significance.

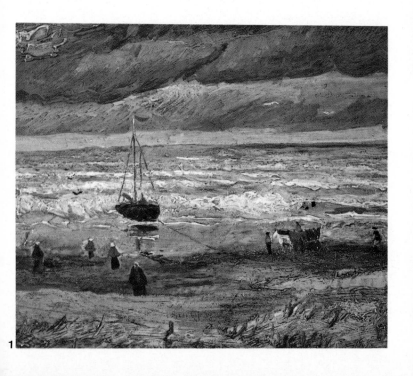

1

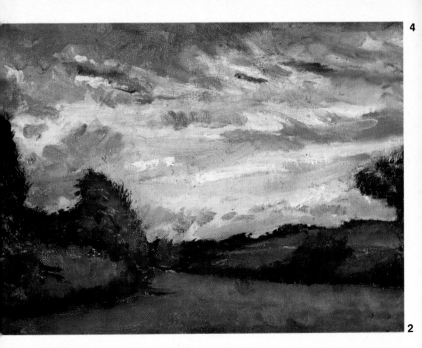

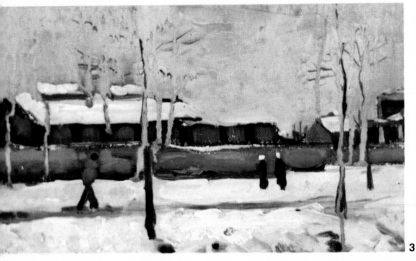

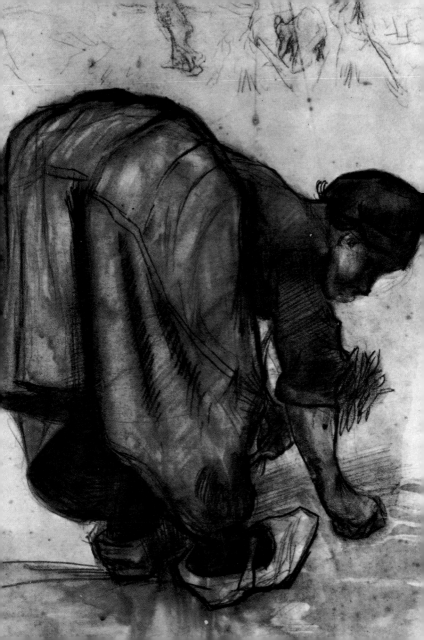

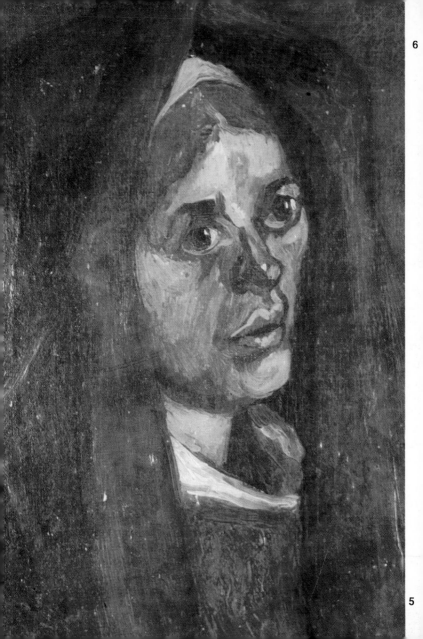

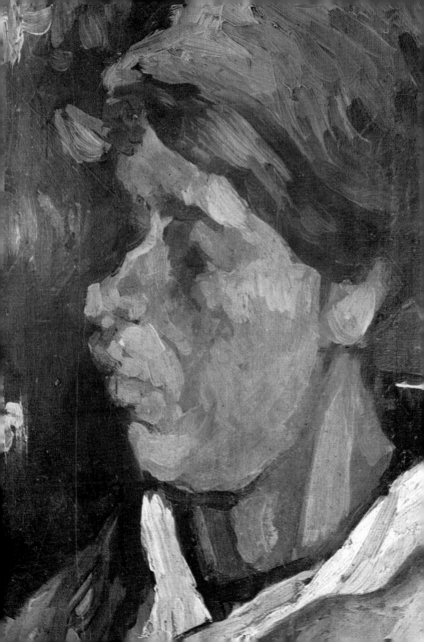

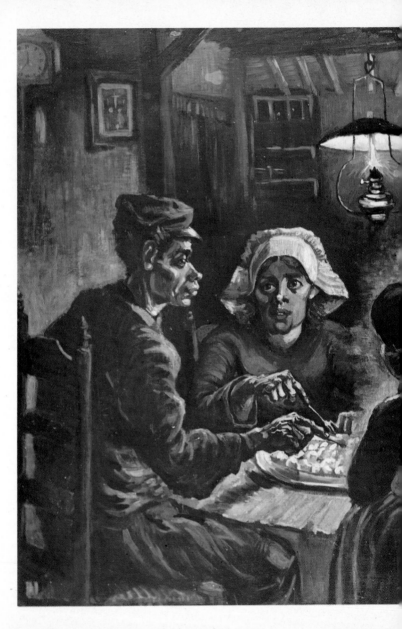

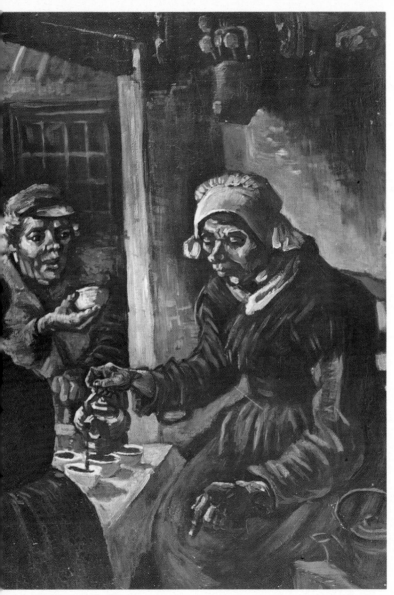

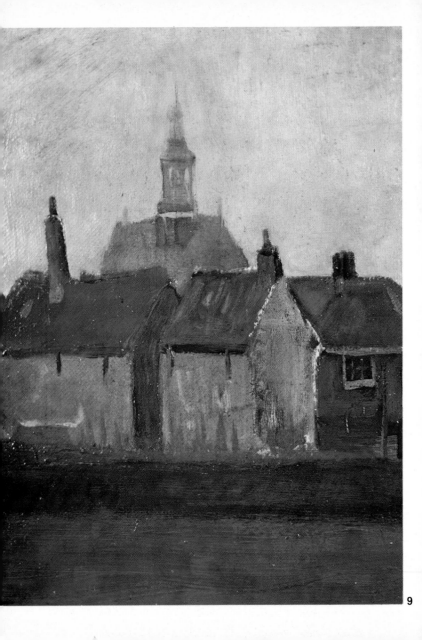

9

10

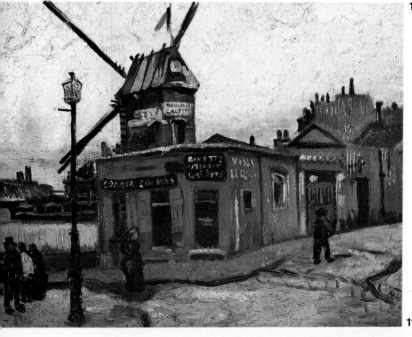

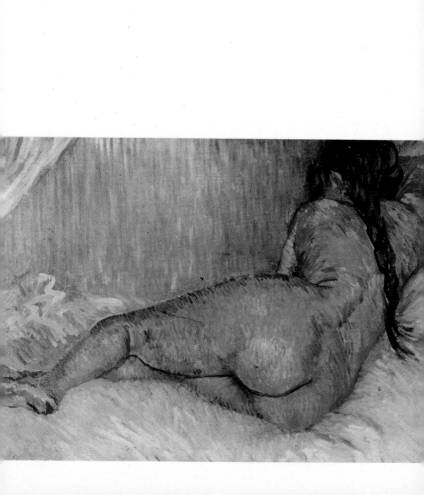

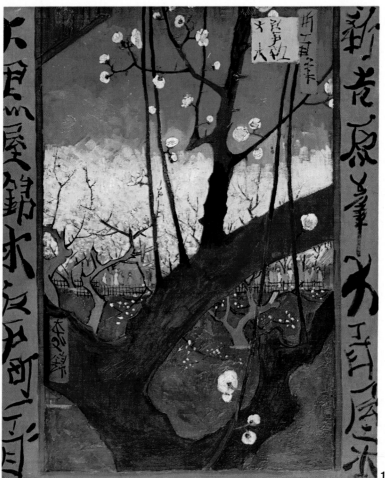

13

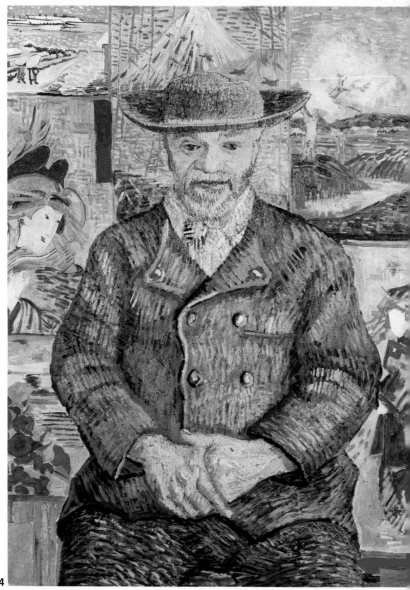

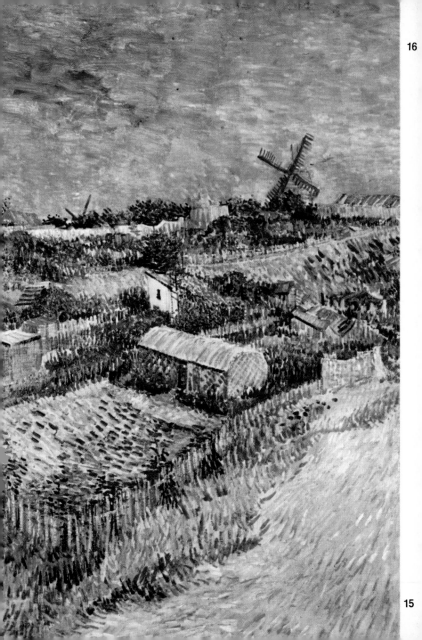

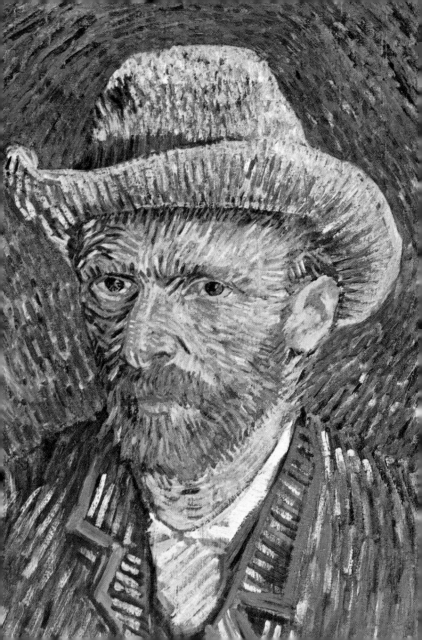

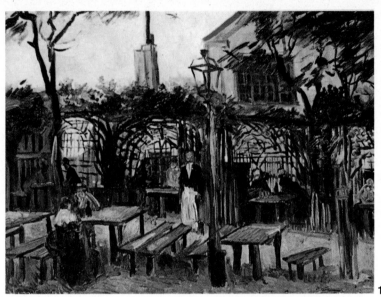

17

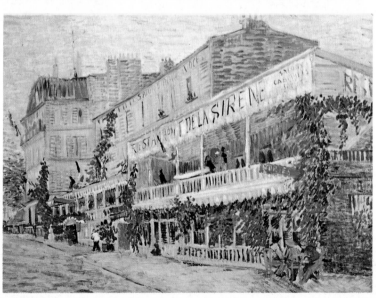

18

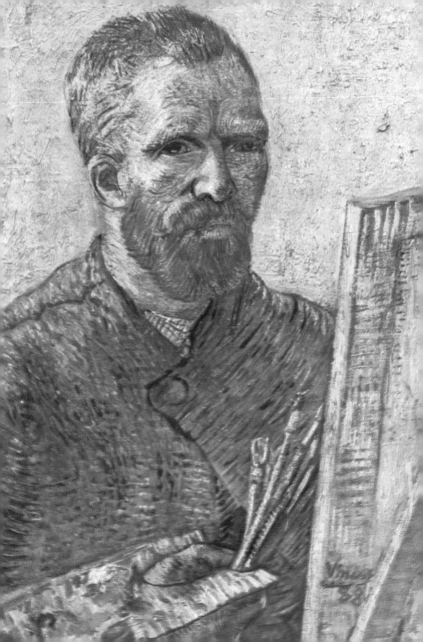

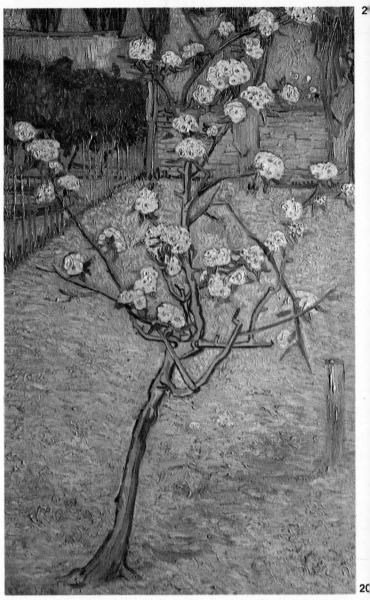

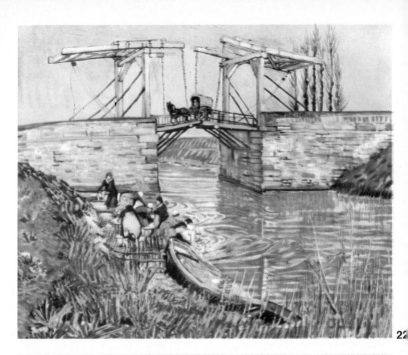

22

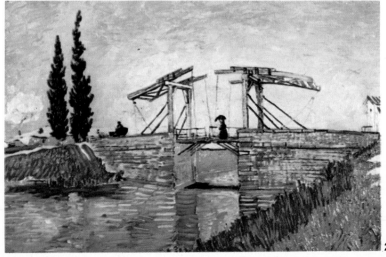

23

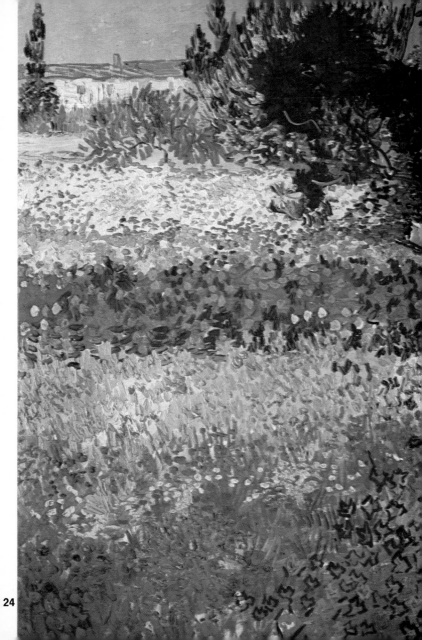

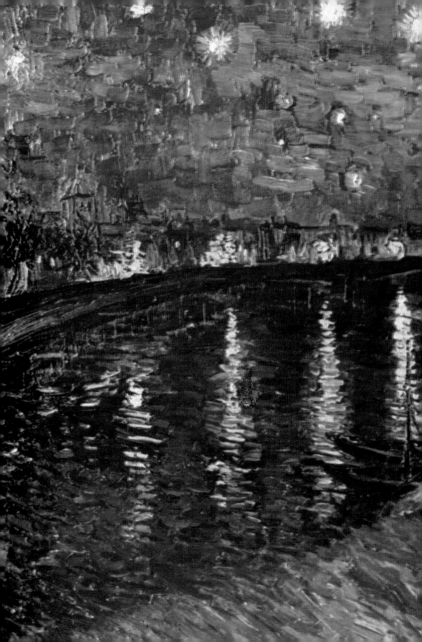

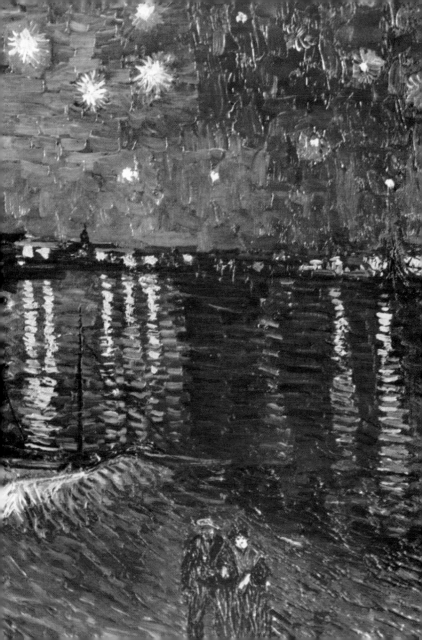

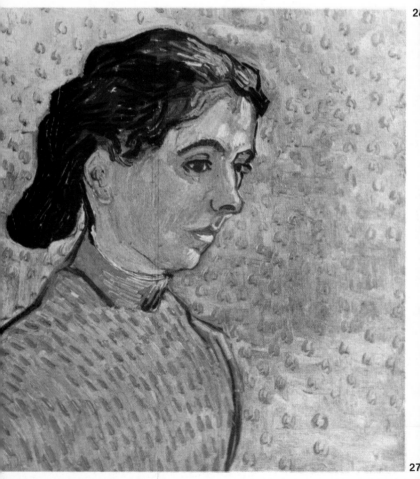

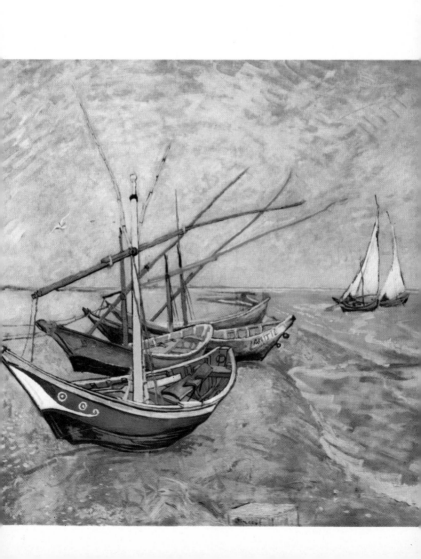

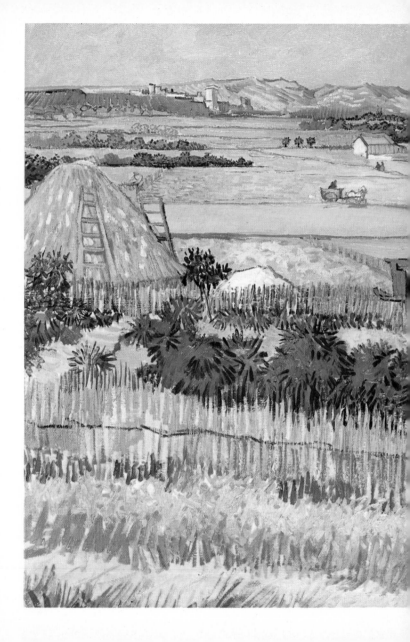

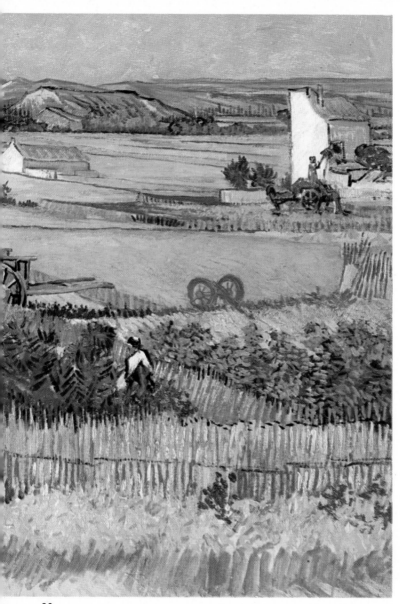

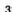
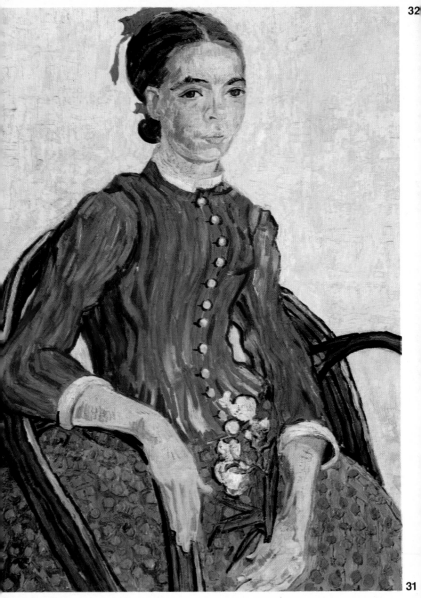

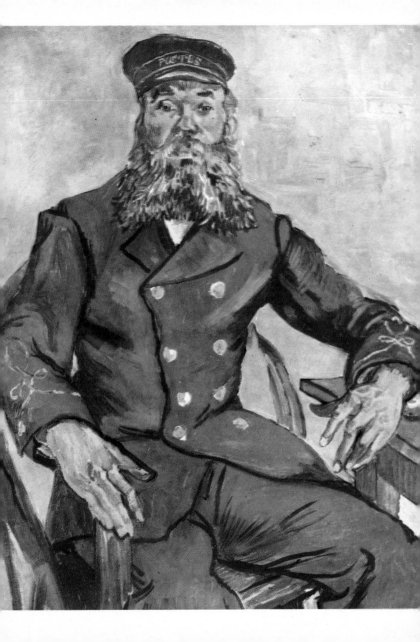

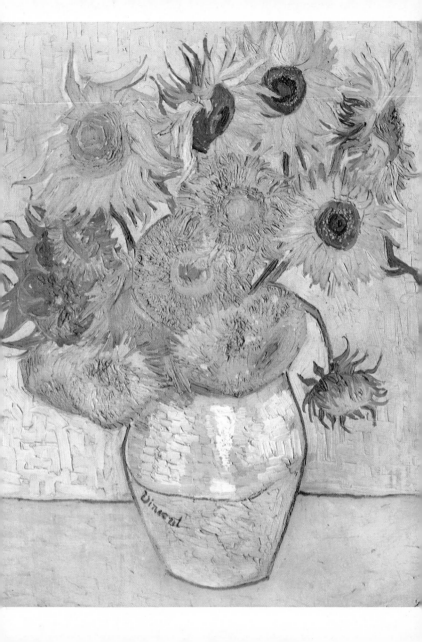

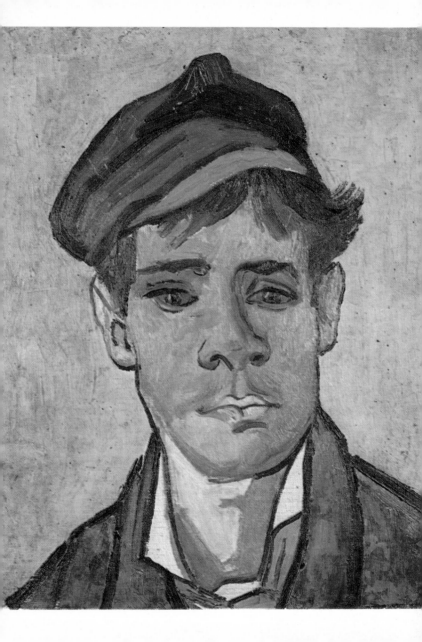

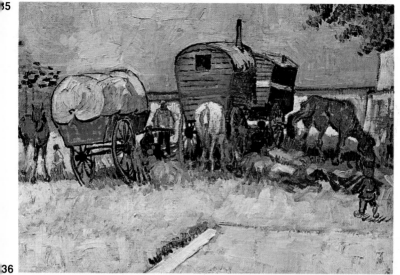

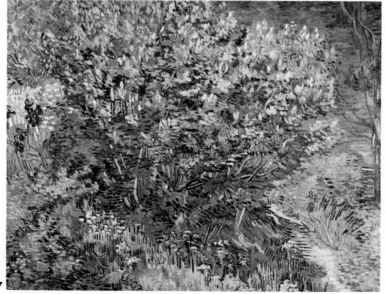

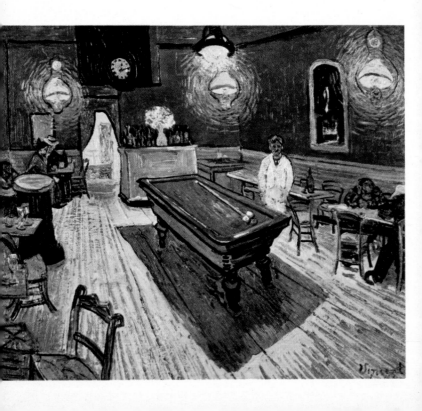

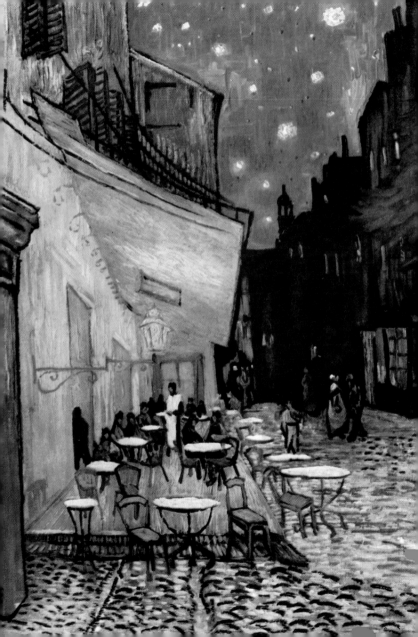

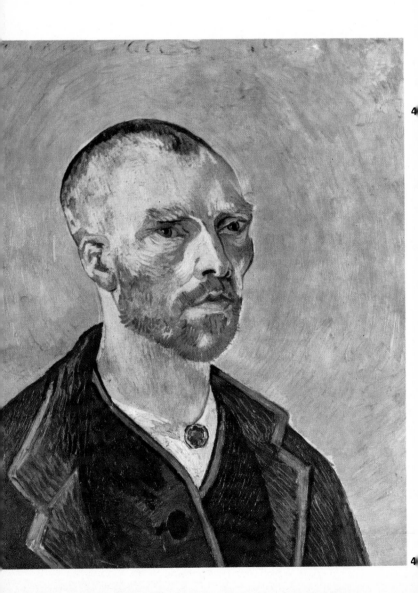

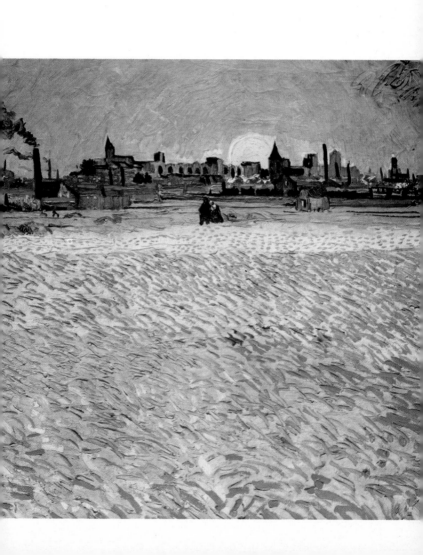

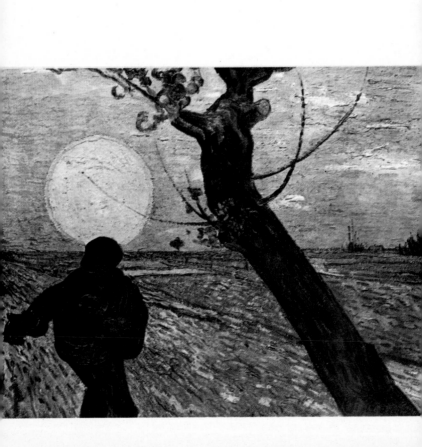

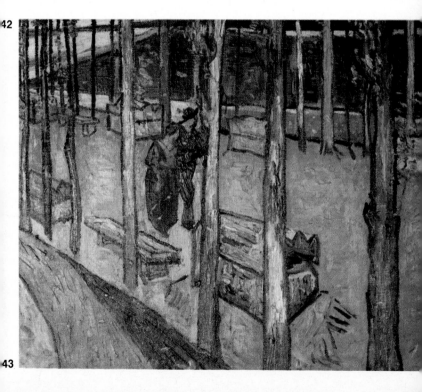

42

43

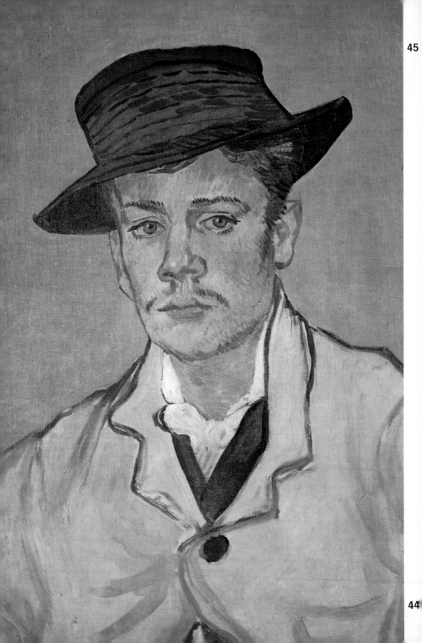

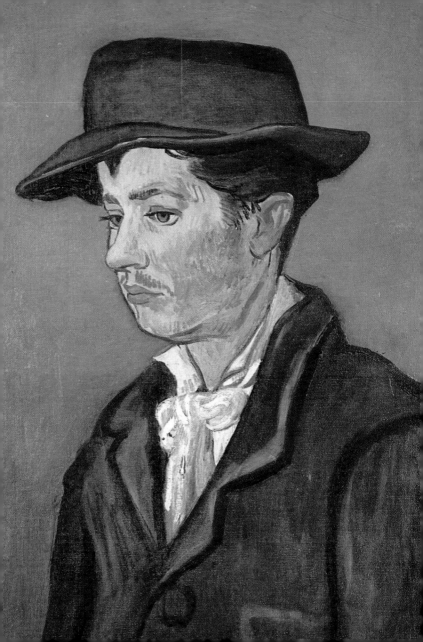

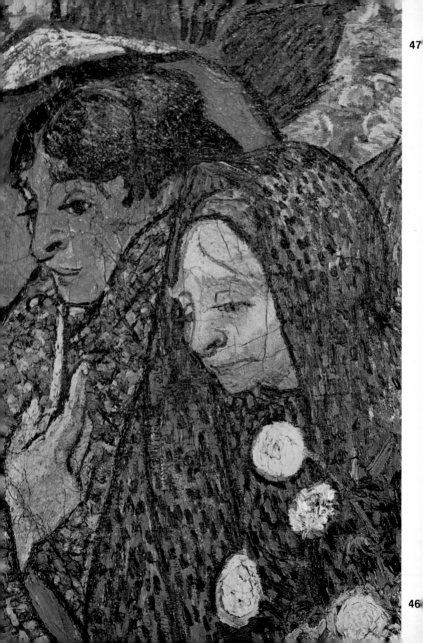

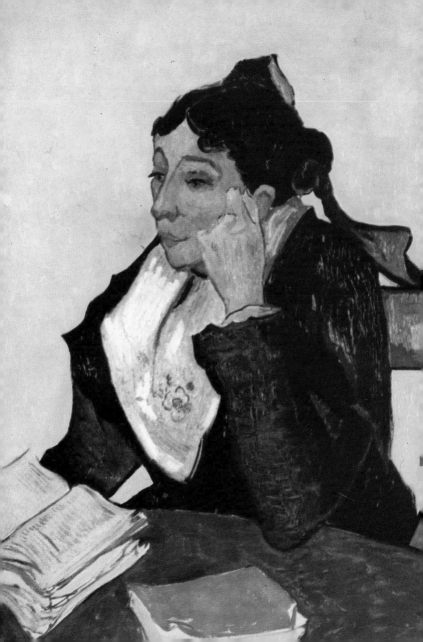

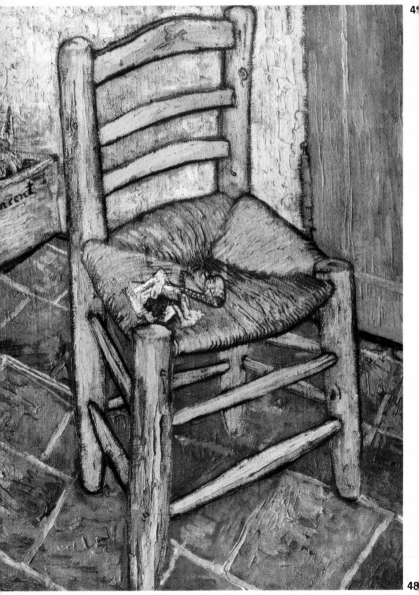

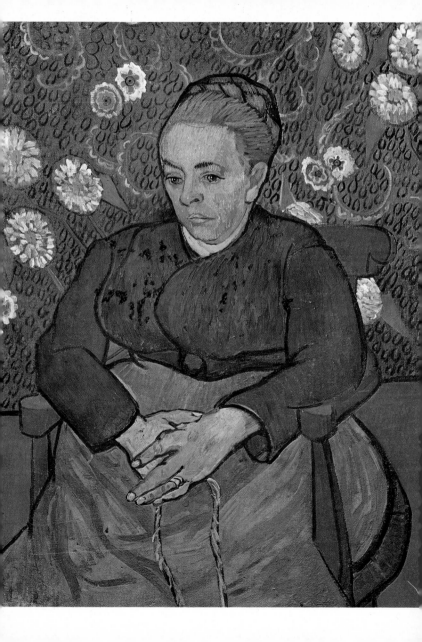

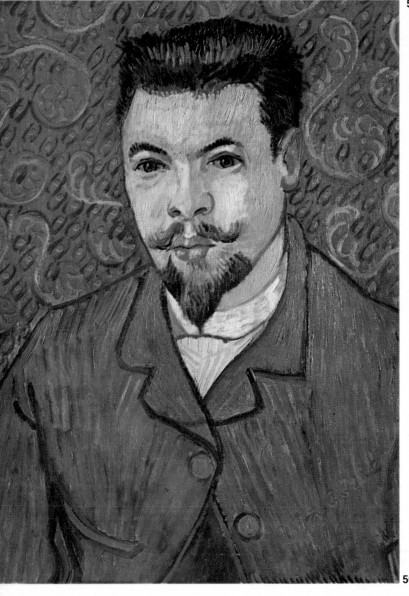

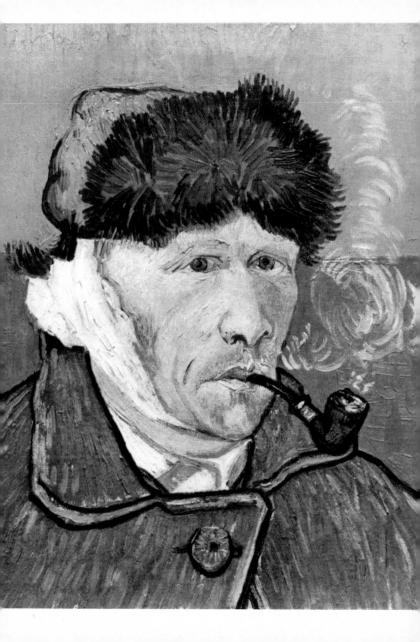

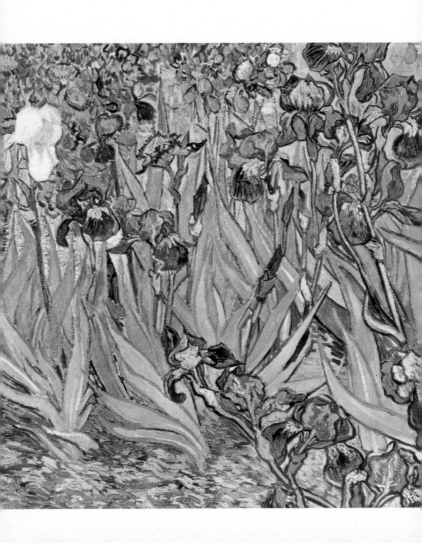

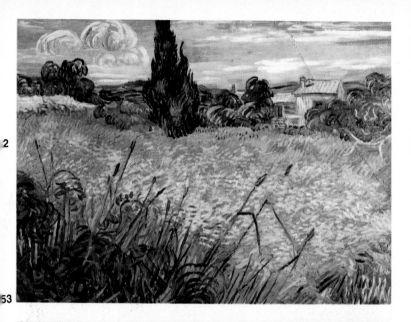

53

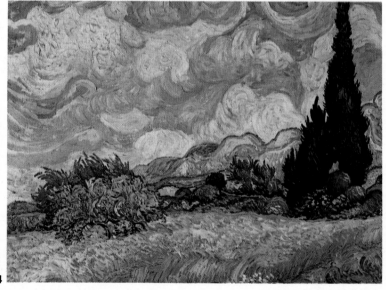

54

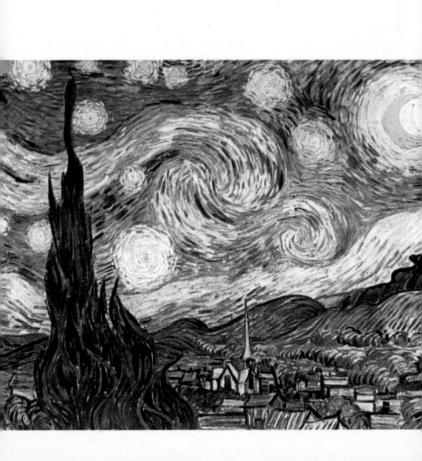

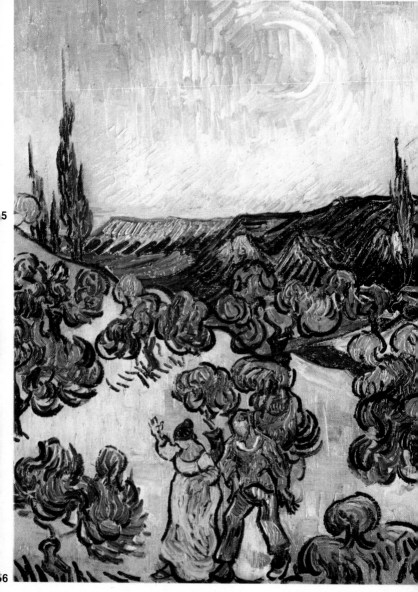

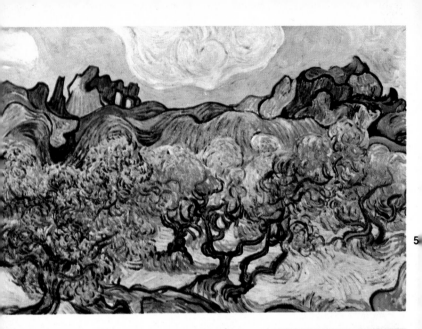

5

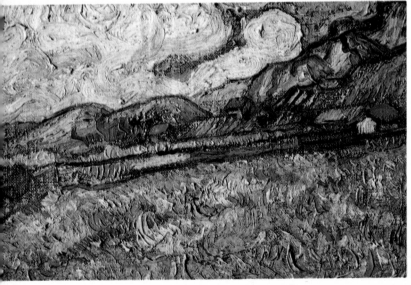

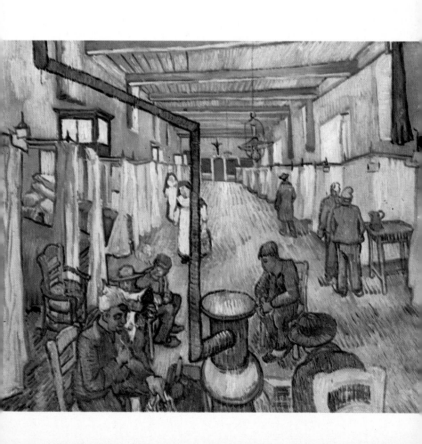

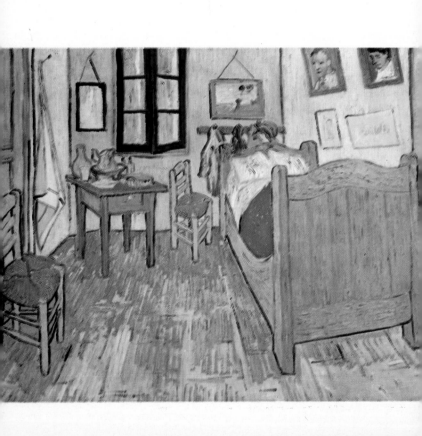

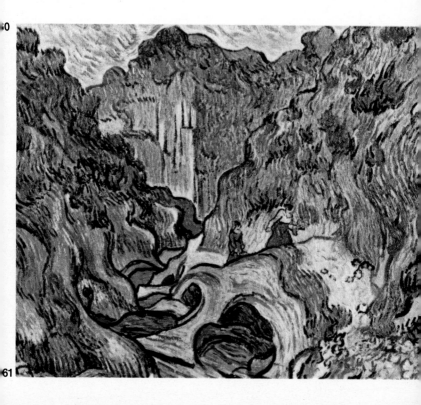

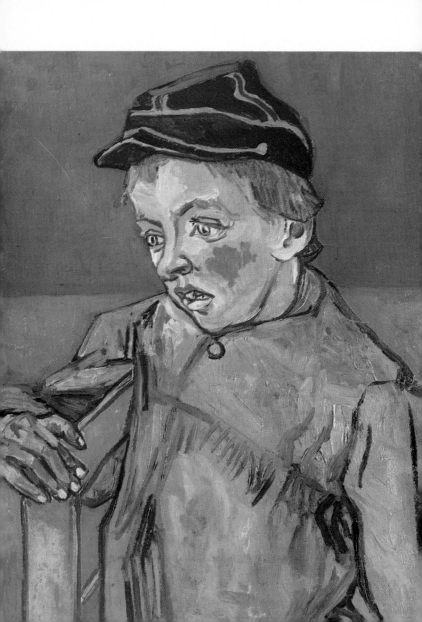

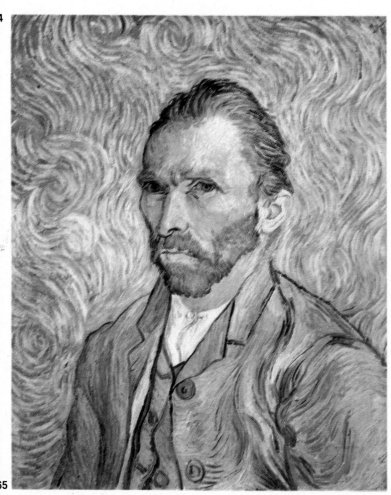

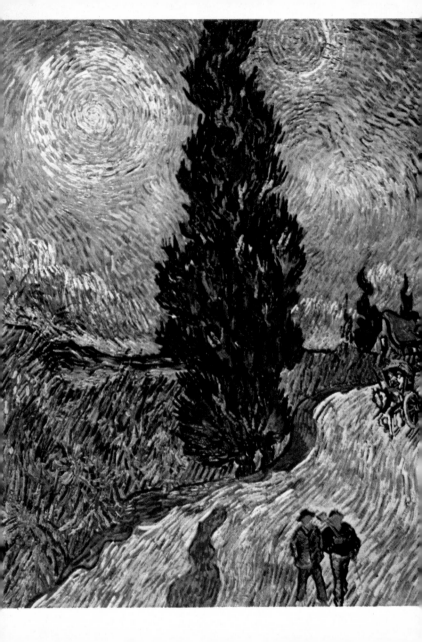

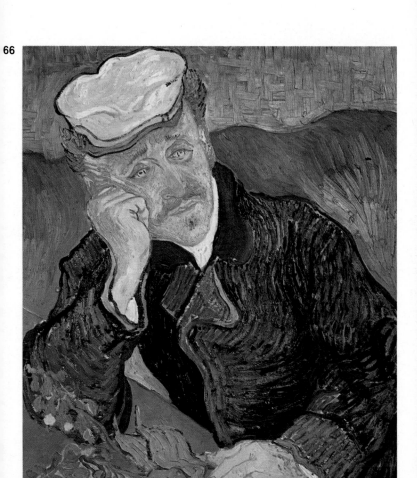

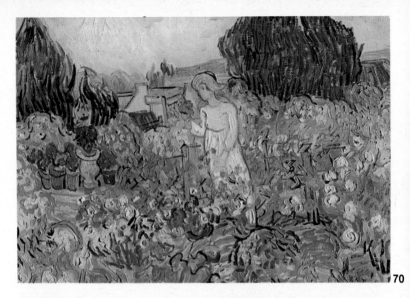

70

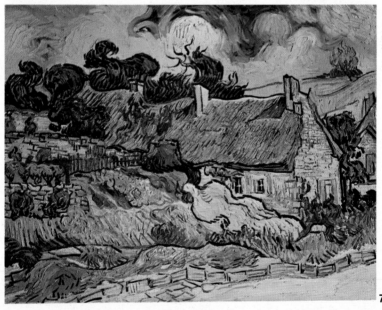

71

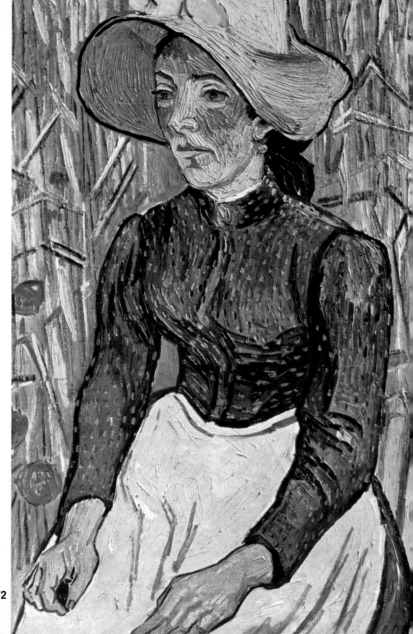

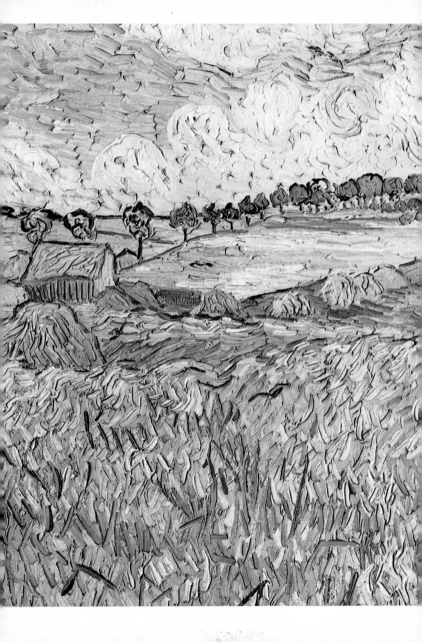

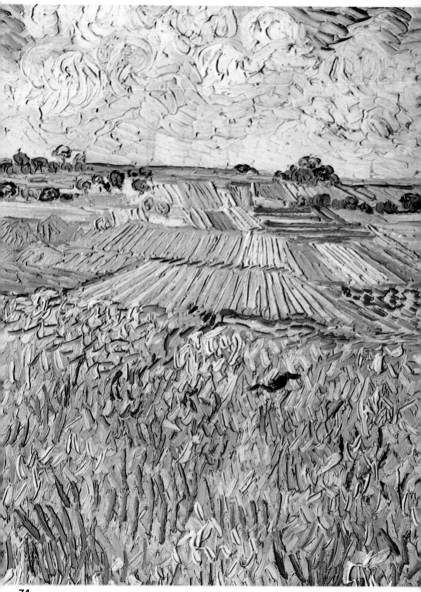

74

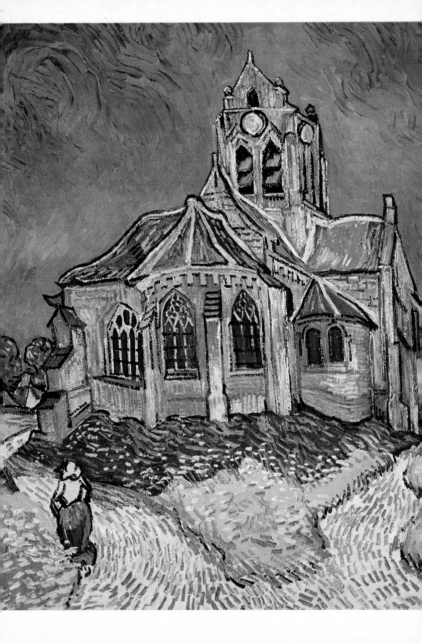

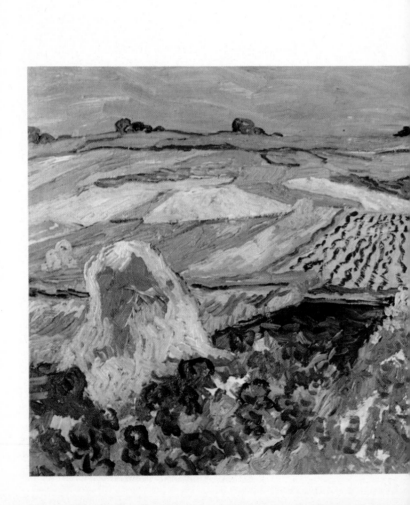

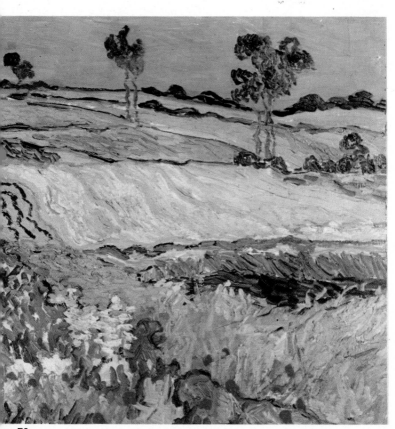

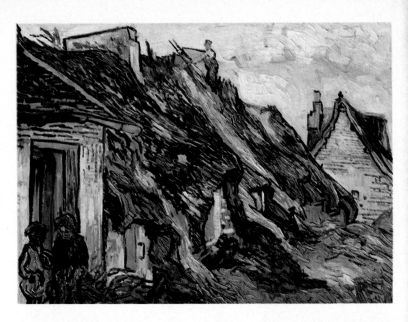

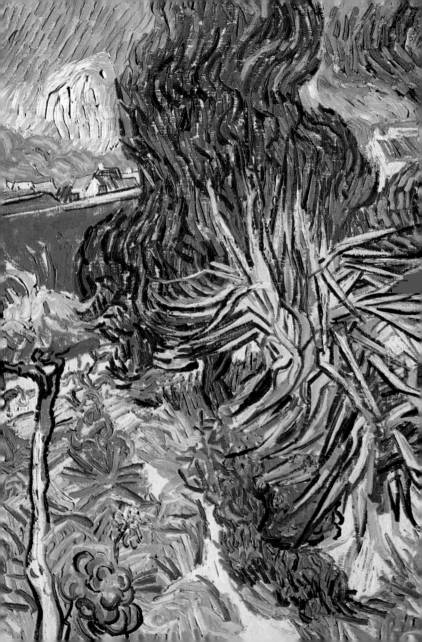

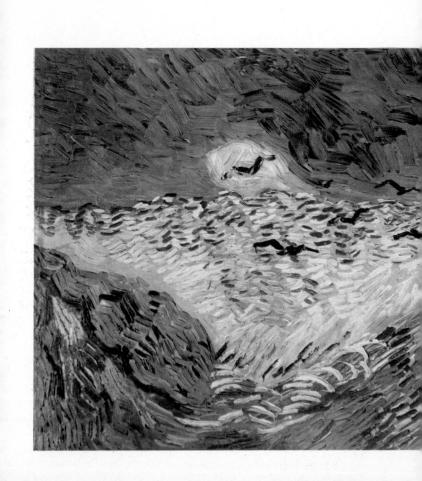

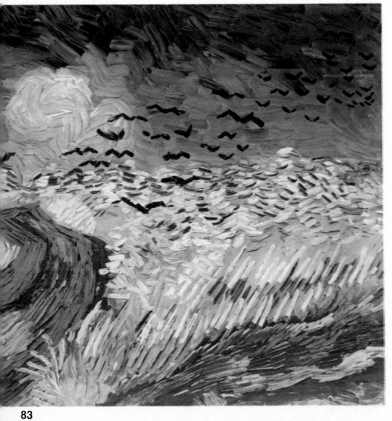

83

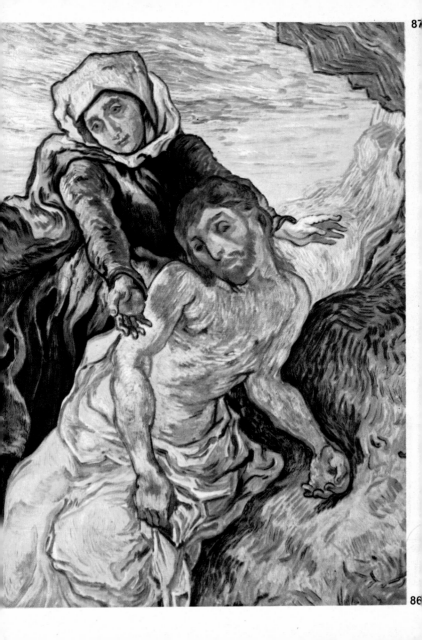

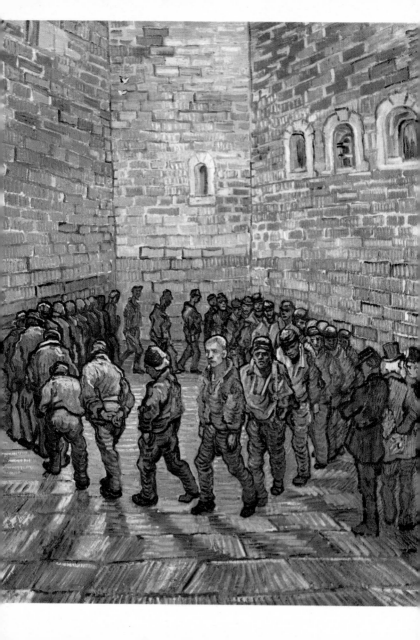